FRIDA KAHLO

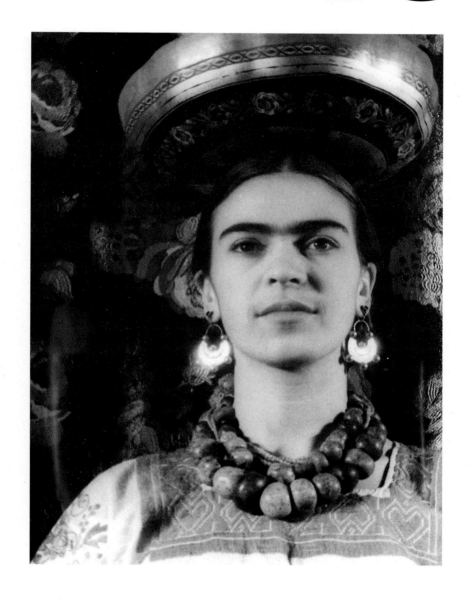

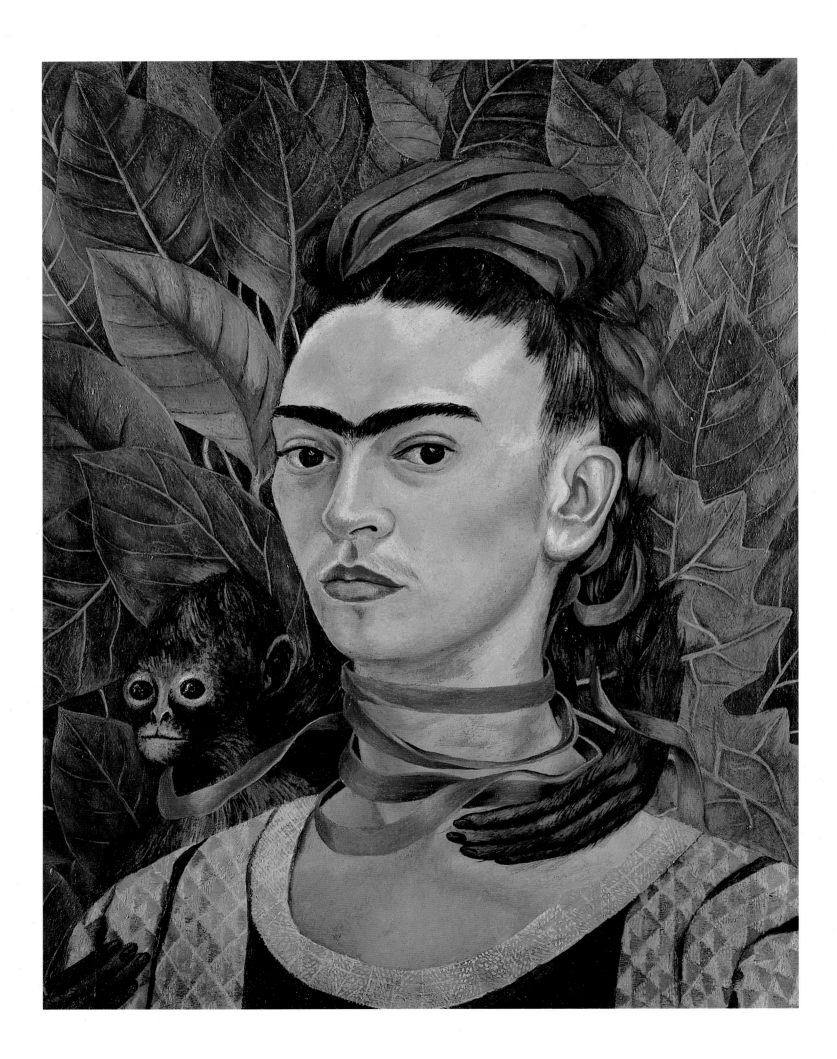

FRIDA KAHLO

Salomon Grimberg

JG PRESS

Published by World Publications Group, Inc.
455 Somerset Avenue
North Dighton, MA 02764
www.wrldpub.net

ISBN 1-57215-323-7

Printed and bound in China by SNP Leefung Printers Limited.

1 2 3 4 5 06 05 03 02

PAGE 1
Carl Van Vechten
Frida Kahlo de Rivera with Headdress, 1932
Platinum Print, 9 1/40 x 6 3/4 in.
Throckmorton Fine Art, Inc., New York, NY

PAGE 2
Self-Portrait with Monkey, 1940
Oil on masonite, 21 x 16 3/4 in.
Private Collection, USA

PAGE 5
Still Life: Pitahayas, 1938
Oil on aluminum, 10 x 14 in.
Bequest of Rudolph and Louise Langer
Collection of Madison Art Center, Madison, WI
Photo by Angela Webster

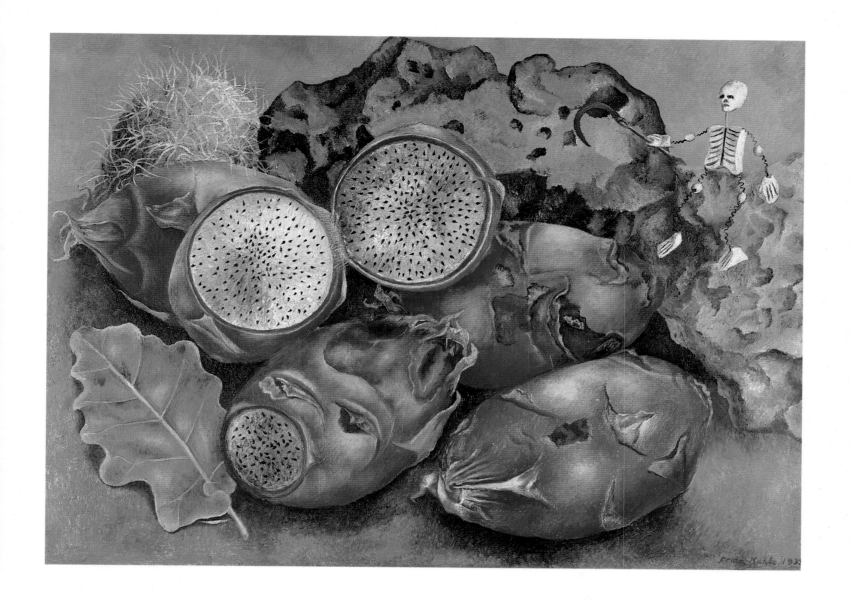

CONTENTS

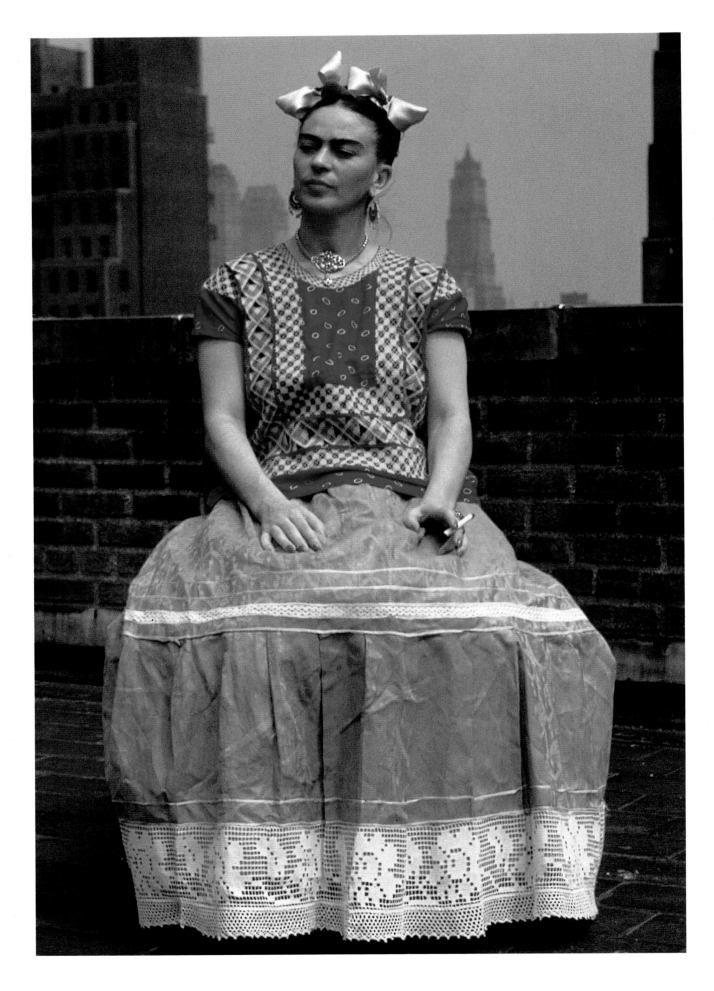

Frida Kahlo in New York, 1946.

FRIDA KAHLO — A FRAGILE THING

Forty-three years after her untimely death, Frida Kahlo (1907–1954) is now recognized as the most popular woman artist in history. The bulk of her ground breaking imagery — deriving from her sterility, her eroticism, her masochism, her self-absorption, and her separation anxiety — was created in the decades of the thirties and forties. Kahlo said she painted herself "because I'm so often alone;" but more than aloneness, Frida Kahlo painted her sense of isolation.

An understanding of her extraordinary life can provide an overview of her work. A native of Mexico, Kahlo said her art arose from three experiences: a bus accident that nearly killed her in adolescence, her inability to bear children, and her tempestuous relationship with Diego Rivera, the artist she married twice. But these are only the bare facts. In reaction to a lifelong sense of inadequacy, of not fitting in, Kahlo continually invented and reinvented herself in order to sustain the attentions of others. She created a timeless persona that was mirrored in her art: a sorrowful heroine whose obsession with death provided her with an unquenchable thirst for life.

Frida Kahlo was born in 1907 in Coyoacán, a small town on the outskirts of Mexico City. In later years, she proudly claimed to have been born in 1910, the year the Mexican Revolution began, but she did this simply to make herself seem younger.

In *My Grandparents, My Parents, and I* (1936), Kahlo painted herself at the bottom on her family tree. A gigantic toddler, a nude Frida stands within the inner courtyard of her home, which

is reduced to a miniature playpen. Each end of the pink ribbon she holds in her right hand travels sideways and upward to form a cradle above her head, to hold the image of her parents that she copied from their wedding portrait. On the left, her mother, Matilde Calderón stares at the viewer, her left arm outstretched gently over the left shoulder of her new husband and Frida's father, Guillermo Kahlo. Growing out of her navel, an umbilical cord is attached to a developing fetus suggesting she was pregnant at the time of the marriage. As each end of the ribbon arrives at the sky, it splits again in halves. Suspended on a cloud on each side are bust-length portraits of each set of grandparents. On the left, Indian Antonio Calderón sits next to

Spaniard Isabel González, on the right the Germans Henriette Kauffman and Jakob Kahlo. Underneath each couple, Kahlo has painted the region where they lived. The Calderóns float above the Mexican Sierra, while the Kahlos rise above the ocean to suggest they had lived in Europe.

In his twentieth year, Guillermo Kahlo had left Baden-Baden, Germany, where he was born, for Mexico, following his mother's death and father's remarriage to a woman he disliked. In Mexico he gave up his German name Wilhelm for Guillermo and the Jewish religion for atheism, and never looked back. Later in his life, Guillermo Kahlo learned photography from Antonio Calderón and eventually earned the title Photographer of the

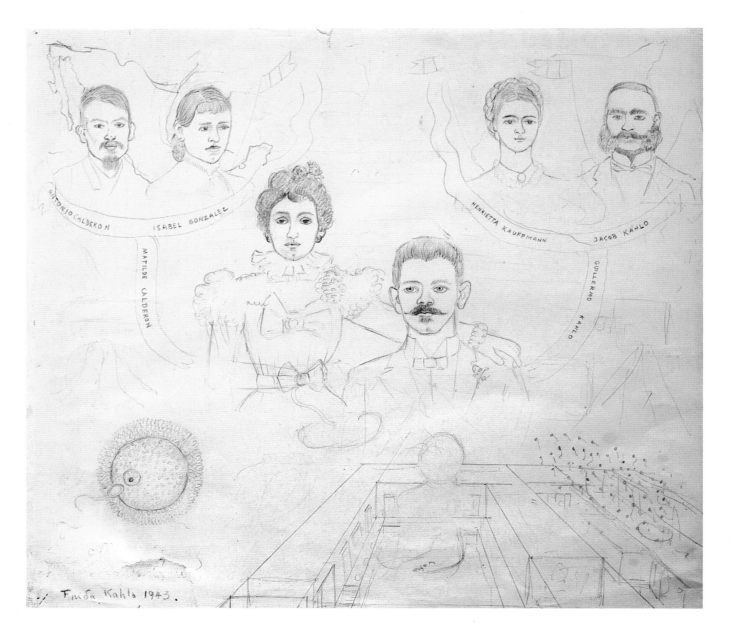

In My Grandparents, My Parents and I (1936), *Kahlo painted herself at the bottom of her family tree as a gigantic toddler. The image of her parents is copied from their wedding portrait and each set of grandparents is suspended on clouds on the sides of the image.*

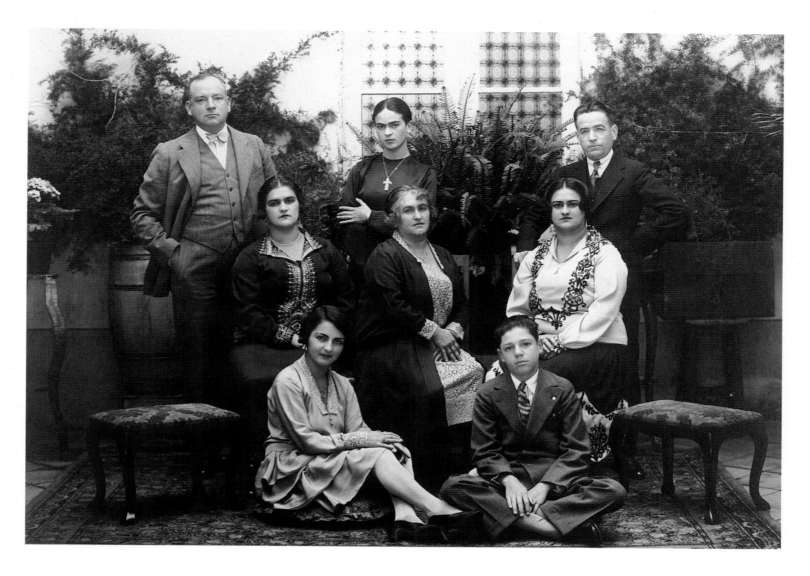

A family portrait: From top left: Alberto Veraza, Frida Kahlo, Francisco Hernández Nieto. Middle row: Maty, Matilde and Adriana Kahlo. Bottom row: Cristina Kahlo and Carlos Veraza.

Nation for documenting Mexican architecture with painstaking care. His legacy has not only historical but also aesthetic value. But before becoming a photographer, he worked for the Diener brothers, German immigrants and friends who owned the fashionable La Perla jewelry store in Mexico City.

Soon after his arrival in Mexico, Guillermo married the devout Catholic María Cardeña, and had three girls with her; the second one died days after her birth and María herself died following the birth of their third infant, leaving Guillermo with María Luisa and Margarita. Frida Kahlo said that on the night of María's death, Guillermo asked for the hand of her mother, Matilde Calderón, a fellow worker at La Perla. Matilde was a beautiful *mestiza* (half Spanish/half Mexican) with finely chiseled features and large brown eyes. She was also bright and determined. Raised by nuns, she had an unbending faith. During the Revolution, when all the churches had been closed, she secreted

the local priest and held Mass in her home despite knowing the risk – penalty of death.

But the Calderón-Kahlo marriage would be an unhappy one. Matilde did not love Guillermo, she later confessed to her young daughter Frida. She merely married him because he was German, and he reminded her of Ludwig Bauer, a young German who killed himself in her presence to prove his love. Following the marriage, Matilde sent María Luisa and Margarita to a nun's school in Cuernavaca, allowing them only sporadic visits home. Guillermo acquiesced to her wishes, he said, to keep the peace at home. Matilde and Guillermo had five children together, the third and only boy dying days after his birth. Their four daughters were Matilde (Maty), Adriana, Frida, and Cristina.

Magdalena Carmen Frieda Kahlo y Calderón was born at 8:30 a.m. on July 6, 1907, and registered on August 4th. Frida later wanted to disassociate herself not only from the year of

her birth, but also from the day, as if her birthday was unlucky. Whenever she was asked, she replied that her birthday was July 7th.

Illustrating Kahlo's insecure feelings about her birth and childhood is her simple but brutal self-portrait, *My Birth*, which she executed following the death of her mother on September 15, 1932. Perhaps her most extraordinary self-portrait, *My Birth* features the body of her dead mother lying on a double bed with her legs bent and knees separated to give birth to Frida.

Frida's head is barely outside Matilde's vaginal canal. The wrinkled sheets are bloodstained and Matilde's body is wrapped from the waist up with what may be a shroud. Above the bed, on the wall, hangs a portrait of the Virgin of Sorrows, weeping and bleeding from neck wounds made by two daggers. "This is how I imagined I was born," Kahlo later explained. The room is empty and there is no sign of life anywhere. In *My Birth* Frida suggests that her chronic loneliness and anxiety began at birth. She painted *My Birth* using the *retablo* or votive painting for-

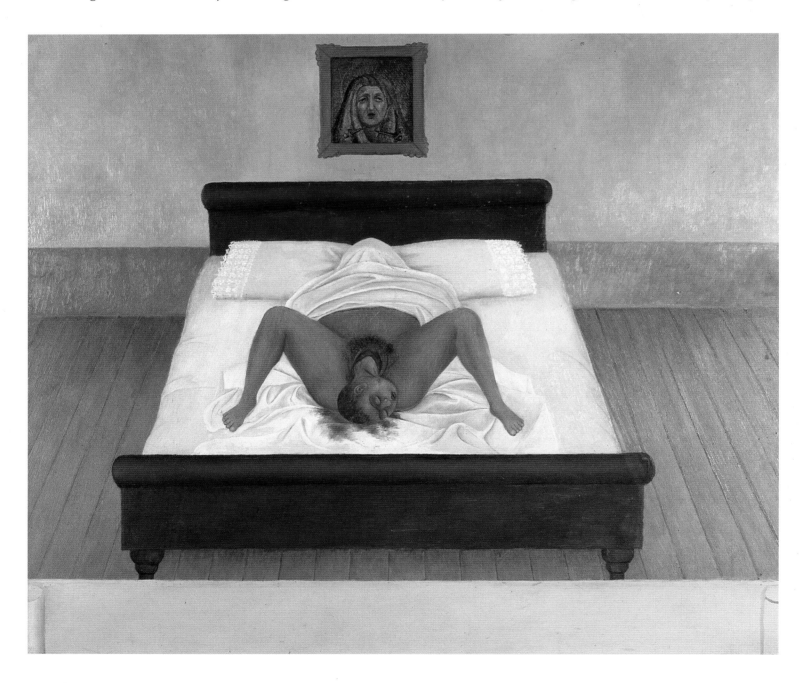

ABOVE: *Perhaps her most extraordinary self-portrait is the simple but brutal* My Birth. *"This is how I imagined I was born," Kahlo later explained. This portrait suggests that Kahlo's chronic loneliness began at birth.*

OPPOSITE TOP: *The goddess Tlazoltéotl giving birth to her son. She was the deity that protected the souls of women who died in childbirth.*

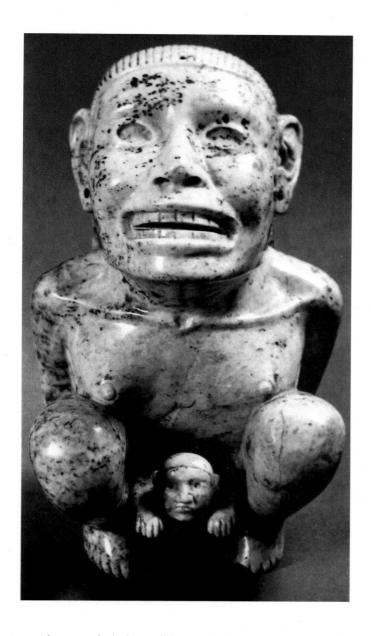

sic image of "mother and child," one imagines a scene of tenderness and intimacy. *My Nurse and I* portrays the opposite. There is no eye contact between the nanny and Frida, no cuddling, not even a sense of attachment; the nanny's face is covered by a mask, and her transparent left breast reveals swollen milk ducts; drops of milk spill onto Frida's unresponsive lips. Frida is listless, self-absorbed, and to the viewer it is not clear whether she is living or dead. The nursemaid holds Frida's small body as if offering her to the viewer; the pose may correlate to the Teotihuacán mask that she wears: Teotihuacán was the Aztec site where human sacrifices were performed.

In *My Nurse and I*, Frida Kahlo reveals that her infancy had been influenced by the effects of an inadequate attachment to a primary caregiver, which was the foundation on which her per-

mat, with an unfurled scroll beneath the image to describe a miracle requested from the preferred deity. Kahlo left the scroll empty, maybe as a way of saying that the miracle she needed could not be granted, even through intervention of the Virgin.

What Frida Kahlo might have requested was the opportunity to have a bonding experience with her mother, which regrettably never took place. When Matilde became pregnant with Frida, she had just lost her only son, a newborn. How deeply she was still grieving during the pregnancy and delivery is hard to appraise; what is certain is that Matilde, too ill to care for or even to feed her newborn daughter, had Frida breastfed by an Indian wetnurse, whose breasts were washed before each feeding. When Matilde discovered that the nanny was drinking alcohol, she fired her and hired a second nursemaid.

Frida Kahlo painted *My Nurse and I* (1937), depicting herself in the arms of an Indian wetnurse. When one thinks of the clas-

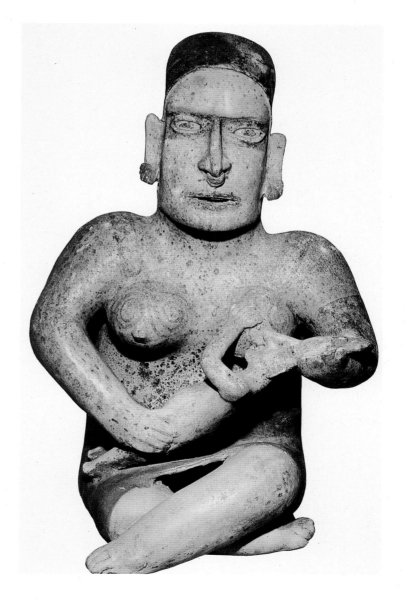

ABOVE: My Nurse and I *was inspired by a Jalisco pre-Hispanic figure of a nursing mother in Diego Rivera's collection.*

sonality developed. Throughout her life, Kahlo was needy, depressive, intolerant of aloneness, and had a constant sense of being a misfit.

Frida Kahlo was six years old when her older half-sister Margarita told her that she was not the daughter of her parents, but was picked out of the trash. The adult Kahlo recalled that those words had such impact on her that she "immediately became an introverted creature." Such words would not have affected her to such a degree unless she already felt that something about her was amiss, and these words merely confirmed it.

Another experience the young Kahlo had during her sixth year reinforced her feeling that she was defective: she suffered from polio and was an invalid for nearly a year, receiving treatments for her right leg, which nevertheless grew thinner. Frida attempted to hide it by wearing pants, long skirts or two pairs of socks on her right foot. But other children teased her calling her

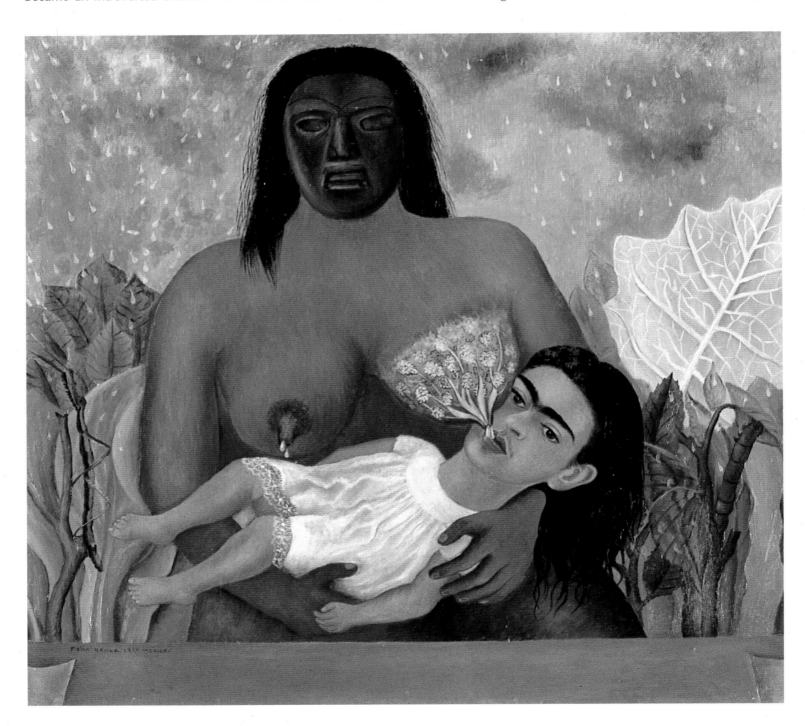

Kahlo painted herself in My Nurse and I *(1937) in the arms of an Indian wetnurse. The classic image of "mother and child" suggests tenderness and intimacy, whereas this painting portrays the opposite, without warmth, cuddling or a sense of attachment.*

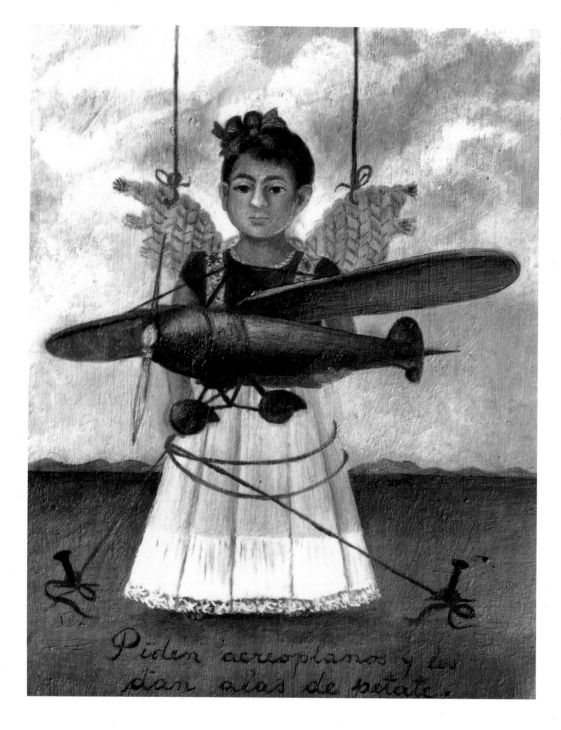

"Frida the gimp" and "Frida peg-leg." In her self-portrait *They Ask for Airplanes and Get Straw Wings* (1938), Kahlo painted herself at the age when she began to wear long skirts after she overheard one teacher tell another, "We need to do something to cover up that leg," when Kahlo was performing in a school play. Kahlo was given a long skirt and a set of straw wings but was disappointed when she discovered the wings did not work. In the painting she therefore appears as if her body, held down by ropes tied to stakes in the ground, was too heavy to fly with straw wings. During the year of her convalescence, Frida noticed how much more attention she was given by her parents and those about her. "Then they really began to love me," she told a friend. Whether consciously or unconsciously, Frida Kahlo grew up from then on believing that only when ill could she get the acknowledgment she needed to feel validated.

Another event that affected Kahlo's health and confirmed her belief that people did for the ill what they would not do for others, took place on September 17, 1925. She suffered a motor vehicle accident, for which she would have over thirty operations throughout her life, ending only with the amputation of her right leg less than a year before her death. Kahlo and Alejandro Gómez Arias, her high school sweetheart, were riding in the back of the bus to Coyoacán after school. Approaching a corner, the bus was rammed in the middle by a trolley. The bus

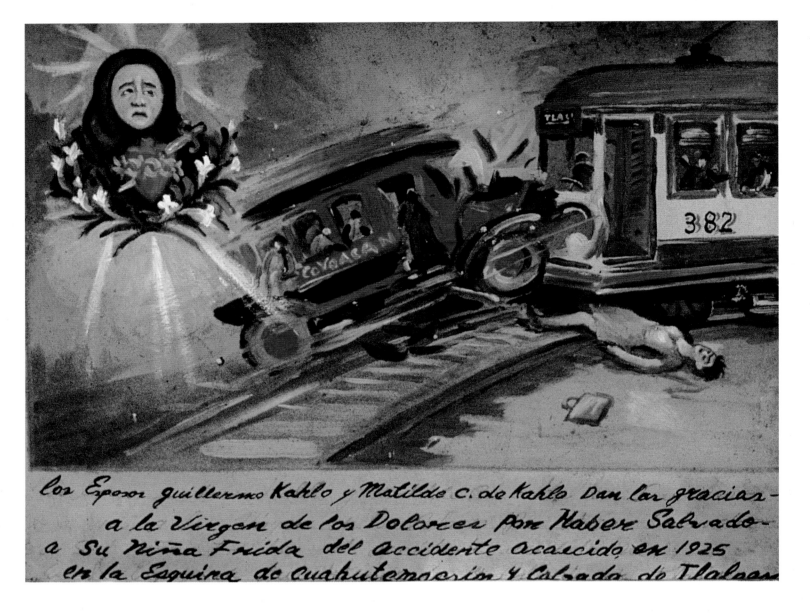

los Eposos guillermo Kahlo y Matilde c. de Kahlo Dan las gracias—
a la Virgen de los Dolores Por haber Salvado—
a Su Niña Frida del accidente acaecido en 1925
en la Esquina de Cuahutemocsin y Calsada de Tlalpan

ABOVE: *Frida reworked a* retablo *she had found by repainting the victims face to resemble her own and writing the miracle performed on the scroll beneath the image.*

RIGHT: *After Frida left the Red Cross Hospital, she painted a cityscape of a small, stark rooftop view. On one of the buildings she painted a red cross.*

broke in half, Alejandro fell under the train, and Kahlo was propelled to the front, where a broken handrail impaled her from one side to the other. The lumbar region of her spine was fractured in three places, her right leg in eleven places and her right foot was crushed. Her collarbone was dislocated, as well as two ribs; her pelvis cracked in three places.

No one could tell during the month that followed whether Kahlo would live or die. Matilde, stunned speechless, could not visit her daughter; Guillermo, ill with grief, took twenty days to arrive at the Red Cross Hospital. The sole family member who visited regularly was Maty, who had run away from home and was living with Alberto Veraza, the man she married. Most of her visitors were her school friends, including Alejandro. When he

did not come to see her right away, she wrote him letters detailing her physical and psychological pain, her surgeries, her loneliness, and her fear of dying. Kahlo parodied her pain and her disquiet with jokes, even pretending that her reason for being at the hospital was to have a child named Leonardo whose godparents, she wrote, were Alejandro Gómez Arias and Isabel Campos.

When Kahlo left the hospital, a couple of months after the accident, she painted some of her earlier documented works, a still life of withering roses, perhaps alluding to her awareness of the ephemeral nature of life, and a cityscape of a small, stark rooftop view. This work shows a building behind which a length of a telephone pole is barely hidden, showing only the very top of the pole, where she painted a red cross. She was

not able to place sufficient distance between herself and the event, so she was never able to paint the accident. But she did successfully make a drawing one year after it took place, and even reworked a *retablo* she had found by repainting the victim's face to resemble her own and writing the miracle performed on the scroll beneath the image.

Frida Kahlo returned to Coyoacán a few months after the accident, and for three months she convalesced at home and hated it. To help her daughter pass the time, Matilde designed an easel that Frida could use while in bed, and placed a mirror under the canopy. From Guillermo, Frida received his box of paints and brushes, which she had coveted while watching him make his dull, academic paintings. But she did not think of paint-

ing seriously until the following year when she produced her ravishing *Self-Portrait with Velvet Dress* (1926), a gift to Alejandro.

She painted herself for the same reason she painted many of her self-portraits — so that she would not be forgotten. No one who met Frida Kahlo ever forgot her, but she never believed it. Even her earlier documented self-portrait, drawn for a schoolmate in 1922, has a plea above her head that says, "I'm sending you my picture so you won't forget me."

Alejandro admired Renaissance art and was the first person to give her reproductions of Old Master paintings. *Self-Portrait with Velvet Dress*, refers indirectly to Botticelli's Venus which Alejandro admired, and when she gave her painting to him she called it "your Botticelli." Frida Kahlo portrayed herself wearing a

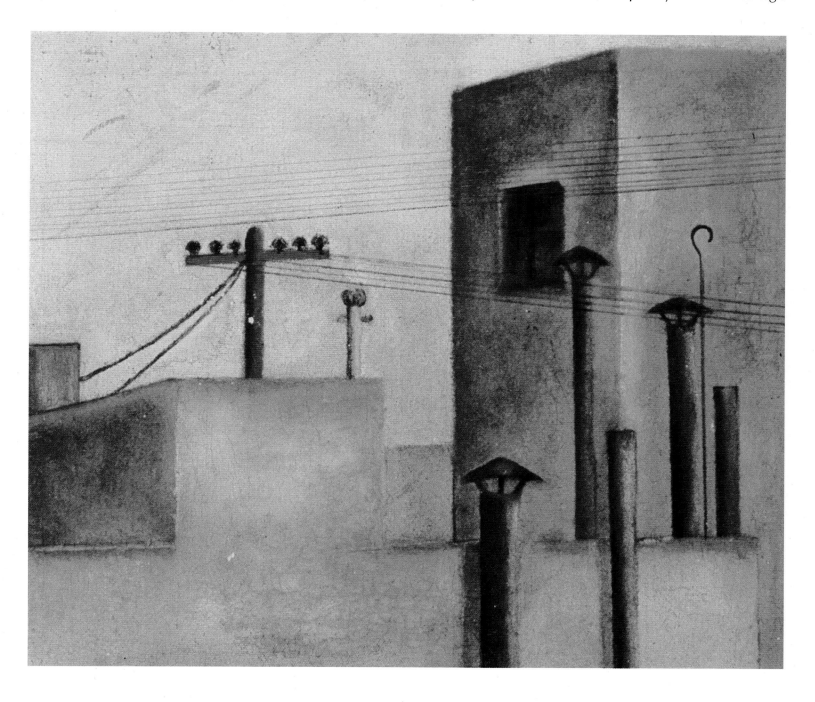

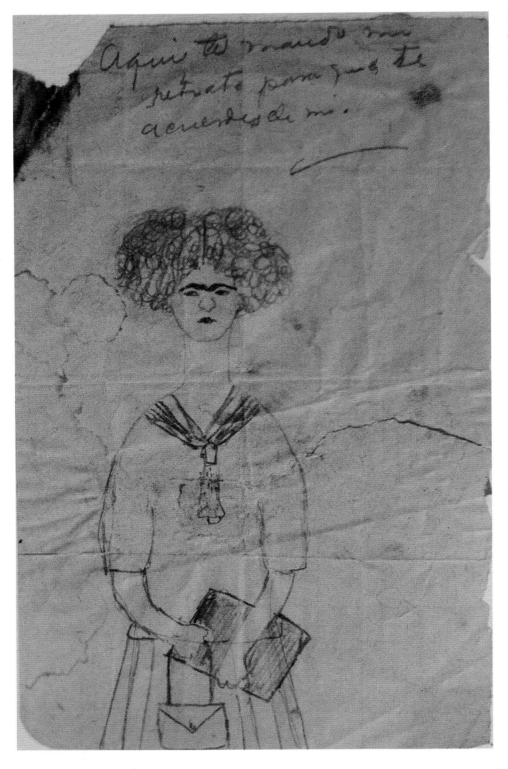

dress she had made herself, with a plunging neckline to accentuate her long neck. Kahlo's posture in the self-portrait is notable, with her head tilted, dreamy eyes, and her right arm across her chest. While in Botticelli's portrait Venus shyly covers her nudity, Kahlo's knowing look suggests her eyes have been opened. The arm that Venus uses to shield her body, Frida Kahlo extends in a beckoning manner. Kahlo needed to feel present in the minds of others; otherwise, she believed, it was as if she did not exist.

A later example of Kahlo's profound sense of isolation is her first self-portrait with a monkey, *Fulang-Chang and Myself* (1937), which she gave to her friend Mary Sklar, during her stay in New York. The gift included a framed mirror the same size as the painting, which Sklar was to hang beside it so that when she stood in front of the two, she would have the impression that she and Kahlo were together.

Self-Portrait with Velvet Dress is a magnetic image. It is difficult for the viewer to avoid the alluring gaze of the sitter, an

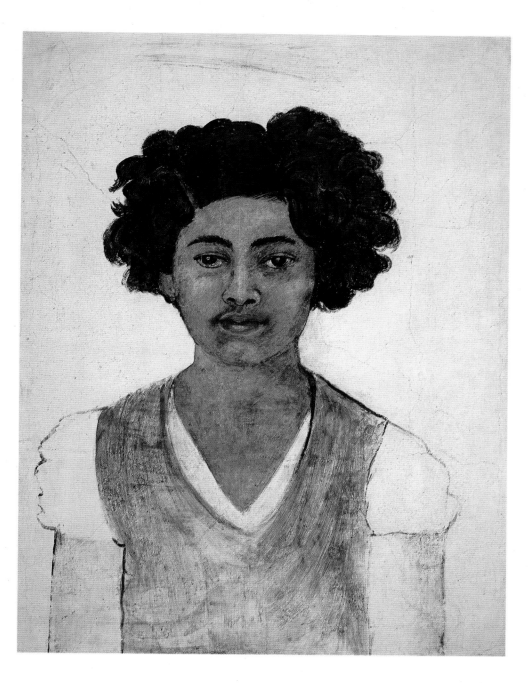

This is Frida's earliest of two attempts to paint al fresco. *Both times they dried before she could finish the paintings.*

invitation to a world of shared intimacy. In her short life, Frida Kahlo painted about sixty documented self-portraits. To be recalled is to be experienced, and one way to spark the other's imagination is to be seen in a self-portrait — particularly one that makes one look as one wishes to be remembered. A most revealing image is the *Self-Portrait Drawing* (1937), originally a gift from Kahlo to her friend, photographer Lola Alvarez Bravo. Here, Frida Kahlo sits drawing while her right arm and hand are shown in a sequence of five postures, arranging her hair, head, chin, dress, and the drawing itself, making certain that the image she leaves with the viewer is perfect and indelible.

Frida Kahlo's love for Alejandro Gómez Arias was doomed. He did not love her back and he misled her. He accused her of being unfaithful, and left for Europe without saying good-bye.

Although Frida never forgot him and they remained friends, when he returned from Europe and tried to rekindle the relationship she was no longer interested. By then, Frida Kahlo had fallen in love again, this time with the most famous man in Mexico — muralist Diego Rivera who was old enough to be her father.

When they met he was 41, she, about 20. Many versions exist of their first formal meeting. Some say they met at the home of Tina Modotti and Edward Weston in 1923, but most likely it was in 1928, after Frida's accident, while Rivera was painting his frescoes at the Ministry of Education in Mexico City. Having finished several portraits of family and friends during her convalescence, Frida was eager for an opinion of her work. She showed them to muralist José Clemente Orozco, who admired her work and

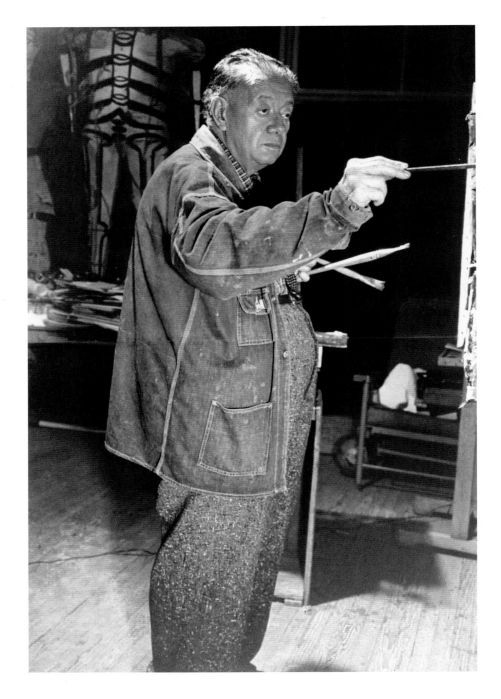

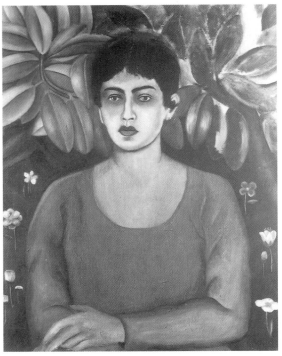

LEFT: *Diego Rivera painting in his Anahuacalli studio, c. 1952.*

ABOVE: *Frida did this portrait of Lupe Marín, Diego's second wife, as a gift to her. Marín destroyed it in anger only to regret it afterwards.*

found her talented, and then to Rivera, calling him down from the scaffolding to see the portraits. He, too, liked what he saw. Little by little Frida Kahlo, who could not live without using others as the axis around which to organize her life, began to seek out Rivera and he began to court her.

Rivera, an ardent communist, had just returned from living for a year in Russia. He had left for the Soviet Union as his marriage to Lupe Marín was failing. Marín and Rivera had two daughters: Ruth and Guadalupe. It was no trouble for Rivera to leave Lupe and the girls behind; he had done the same to Angelina Beloff in Paris, his common-law wife and mother of his first child, Michelangelo, with an empty promise to send for her later. He never did. When many years later Beloff arrived in

Mexico, she and Rivera ran into each other at a concert, and he walked past her without recognizing her. In Paris, he had also left a lover named María Vorobiev, "Marevena," and their daughter Marika. Having shown prodigious talent since childhood, Rivera went to Europe in 1907 to complete his art education, and returned to Mexico in 1921 after working with and befriending some of the great personalities of the time: Pablo Picasso, Amedeo Modigliani, Chaim Soutine, Tsuguharu Foujita, Sergei Diaghilev, and Elie Faure.

Frida Kahlo must have grown bedazzled not only by Rivera's larger than life personality, but also by his fame. While in preparatory school she had fallen head over heels in love with Alejandro who was a student leader; having him for a boyfriend

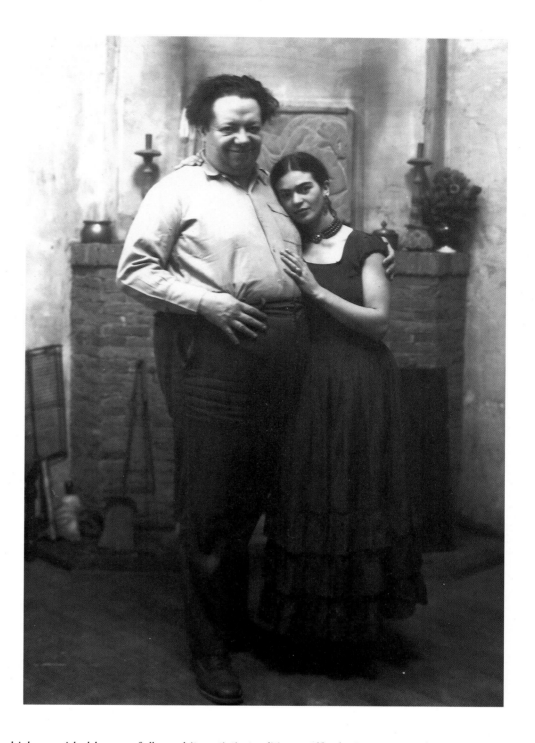

protected her and gave her a unique place, which provided her with a feeling of being special and distracted her from feeling like a misfit. Being a lover of Rivera's again fueled a sense of uniqueness by the mere fact that he had chosen her over many others. But although Frida Kahlo played a special role in his life, Diego Rivera was an incorrigible philanderer, a compulsive liar who could alternate from being gentle and tender to being gratuitously cruel without provocation or a second thought. Diego Rivera, Kahlo came to believe, was amoral rather than immoral.

When they met, in 1928, Mexico was undergoing an extraordinary transformation as it rediscovered its native roots. A new generation of artists acknowledged pre-Hispanic and folk art and followed its artistic traditions. Alfredo Ramos Martínez, a painter and director of the San Carlos School of Painting, discouraged artists from following foreign influences, urging them to turn instead to native Mexican concerns and subjects. Frida Kahlo's painting *Two Women* (1929), the first work she sold, was directly influenced by Ramos Martínez. It features portraits of finely drawn, clear-featured Mexican women shown in front of a tight curtain of leaves. Frida Kahlo quickly assimilated the immediacy of Ramos Martínez's style as well as his use of a claustrophobic background which pushes the image out towards the viewer. Kahlo employed these devices in her works repeatedly for the next twenty years.

Frida Kahlo's interest in Mexican subjects or *mexicanidad,* was influenced primarily by her relationship with Diego Rivera. With him, she had found the sense of security that she could not generate from within; and in order to keep him she molded herself to meet his needs. He could not get enough and she gave him more, and more, and more — without considering that she was losing something precious in the process: her true self. Kahlo became an invented being, which is in fact what a lover she met in early 1946 liked to call her.

Frida Kahlo and Diego Rivera were married in 1929 in a small ceremony. She wore a dress borrowed from one of her maids, and in one of the wedding portraits, arm in arm with Rivera, she holds a cigarette. Her inevitable transformation was gradual but certain. One day, her friend Alfa Rios, wife of poet Andrés Henestrosa, gave Kahlo a colorful costume from the Tehuantepec region of Mexico and when Rivera saw her dressed this way he was mesmerized by her appearance, which hearkened back to the matriarchal society of the Tehuantepec Indians, free of bourgeois influence. To please Rivera, Kahlo began to dress exclusively in Tehuana clothing. The long skirt of the costumes served to cover her shorter, thinner right leg, and she further enhanced her exotic beauty with pre-Hispanic adornments, brightly colored ribbons and combs in her braided hair.

Rivera's influence extended to Kahlo's painting. Appreciative of her innate talent, he encouraged her to paint. Kahlo often complained of boredom and Rivera's retort was invariably, "paint."

Frida Kahlo might have been pregnant at the time she and Rivera married or she may have become pregnant soon afterwards. In any case, she had the pregnancy terminated. It was not a good time in the marriage. Rivera did not want children partly because painting commissions obliged them to travel a great deal. The Riveras moved to Cuernavaca where American Ambassador Dwight Morrow had secured a commission for Rivera to paint a mural in the Palacio de Cortés to celebrate Zapata's rebellion. Perhaps in Cuernavaca Frida Kahlo's eyes were opened to what the future with Rivera might entail. He worked indefatigably, but he managed to find time for a romantic liaison with his assistant Ione Robinson. There was nothing Kahlo could do. *Her Self-Portrait* (1930), the first work done after

the marriage – probably while in Cuernavaca – foretells the emotional content of the self-portraits to follow. She presents herself as beautiful but hard, which is noteworthy because in photographs from the period she appears much softer. Self-absorption had become the emotional content of the imagery that became her signature style.

As Rivera finished work in Cuernavaca, a commission for a mural for the San Francisco Stock Exchange allowed Rivera and Kahlo temporarily to leave behind the hostile attitude towards him in Mexico. Like many other communist artists, he was often threatened with whitewashing of his murals and could have been jailed or even murdered. The invitation to the United States could not have been timelier. Rivera believed that the

Frida Kahlo painting her Portrait of Mrs. Jean Wight *in 1931.*

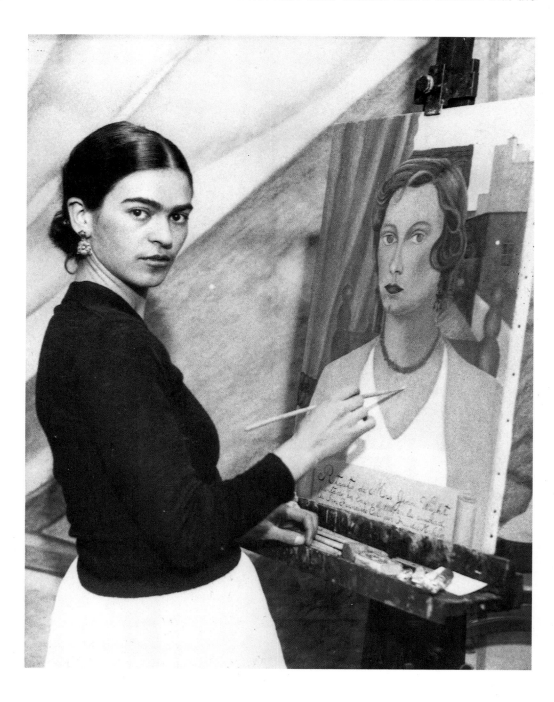

great communist revolution would take place in the United States, and he wanted to be there when it happened.

In November 1930 the Riveras arrived in San Francisco, where Rivera was to teach at the California School of Fine Arts. They lived at 716 Montgomery Street, a building occupied by other artists. A photograph taken soon after their arrival shows artists Lucile and Arnold Blanch with the Riveras. Lucile is sitting on Diego's lap and Frida on Arnold's. Rivera worked tirelessly as usual and encouraged Frida to do the same. During that year she, too, worked hard, and painted if not mature works certainly strong ones, conveying skill and sensitivity to her subjects. The portrait of Eva Frederick, which she must have begun before leaving Mexico, is a dignified rendition of a black professional model who had posed in Mexico for Rivera and other artists including photographers Lola and Manuel Alvarez Bravo and Edward Weston. Frida Kahlo also did portraits of Cristina Hastings and Jean Wight, both wives of Rivera's assistants. Perhaps one of her most successful paintings from the period is her *Portrait of Luther Burbank* (1931). Rivera was painting

Burbank's portrait in his mural at the San Francisco Stock Exchange at the same time, and although one can see Rivera's influence, Kahlo's portrait is nevertheless her own.

Yet, the work that seemed to interest viewers most was the double portrait *Frida Kahlo and Diego Rivera* (1931). The work was commissioned by Albert M. Bender, a Rivera collector who had been influential in getting Diego a visa to enter the United States – something usually denied to communists. Later, when Bender died, he bequeathed the portrait to the San Francisco Museum of Modern Art. Today, it is a magnet for visitors; however, when it was finished in 1931, one of the San Francisco newspapers described the work as being valuable only because it was painted by the wife of Diego Rivera.

The painting portrays a large Rivera standing with his feet apart, and his palette in one hand. The other hand holds Kahlo's hand, who stands by him without any other attribute but her *rebozo* (a traditional Mexican shawl) draped on her shoulders. Above them a bird suspended in mid air holds a ribbon on which Frida Kahlo wrote how she came to paint the work. The

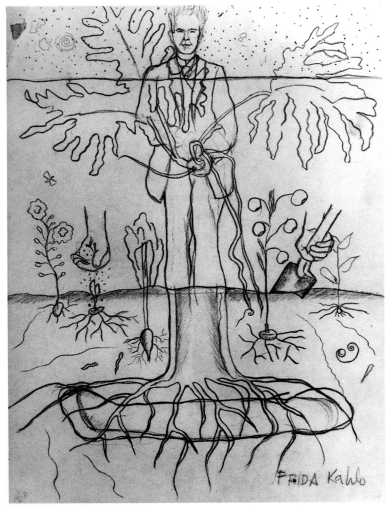

LEFT: *Frida's image of Luther Burbank was inspired by Diego's portrait of Zapata buried with his body feeding growing corn stalks in his Chapingo Chapel mural.*

RIGHT: *Kahlo painted* Portrait of Luther Burbank (1931) *while Diego included one as well in his mural at the San Francisco Stock Exchange.*

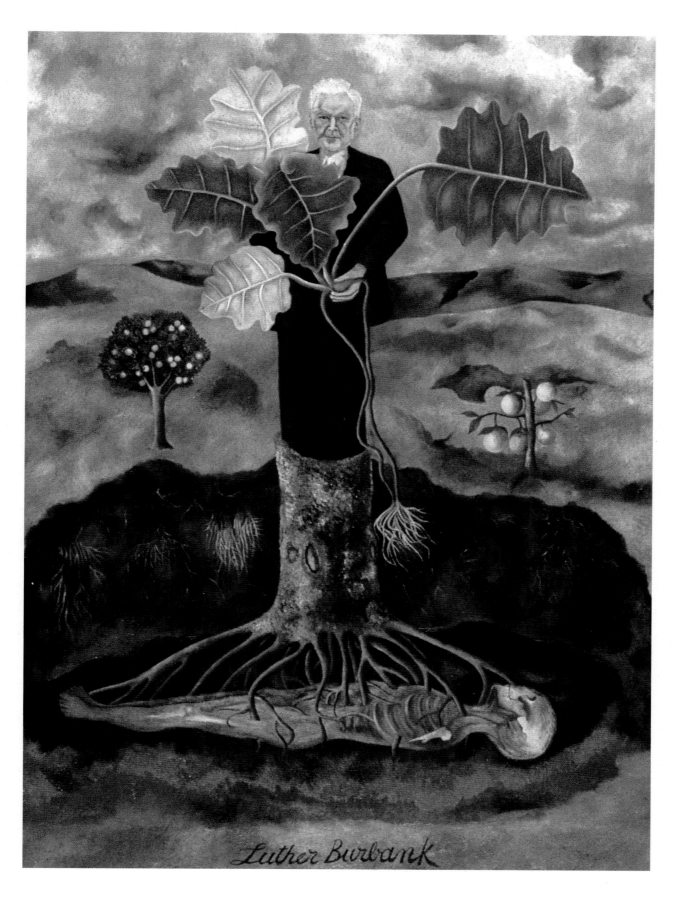

Luther Burbank

painting that inspired the double portrait was Van Eyck's marriage portrait of Giovanna Cenami and Giovanni Arnolfini. They had commissioned it originally as a kind of votive painting requesting that a child be granted to them. Their wish never materialized — just as in the case of Kahlo and Rivera. In the preparatory sketch for this painting, Kahlo had drawn very lightly a fetus within her.

During this period, Kahlo also painted a portrait of Dr. Leo Eloesser, done from a snapshot. Dr. Eloesser stands beside a small sailboat inscribed *Tres Amigos*, a reference to him and the

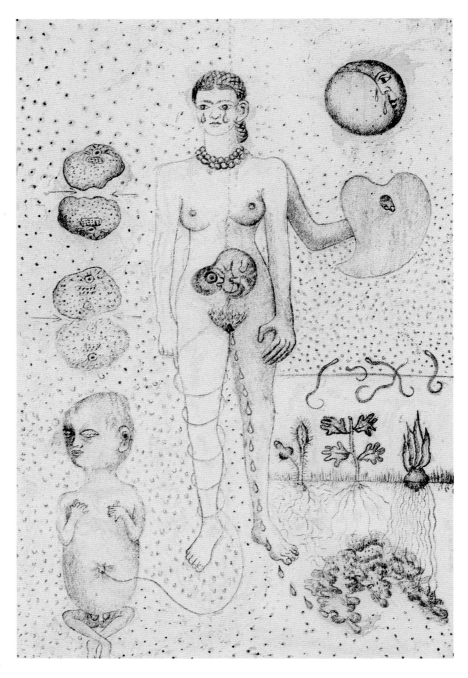

LEFT: Frida and the Abortion *is the image with which Kahlo forged her signature style. She created the lithograph following the abortion she had in Detroit in 1932.*

OPPOSITE TOP: *For* Henry Ford Hospital, *Frida used the* retablo *or votive painting format, as she would later for several self-portraits.*

OPPOSITE BOTTOM: Henry Ford Hospital *portrays Frida Kahlo's loss of her second pregnancy.*

Riveras. In 1939, the year in which the Riveras divorced, it was Dr. Eloesser who convinced Rivera to reconcile and marry Kahlo a second time. In gratitude, Frida painted for him an extraordinary self-portrait wearing a haunting look and a crown of thorns for a necklace. The painting features the flowers and colors associated with images of Saint Joseph, perhaps alluding to Eloesser's fatherly role. Beneath her face, a ribbon pulled by a tiny hand reads the words "I painted my portrait in the year 1940 for Doctor Leo Eloesser my physician and my best friend. With all my love, Frida Kahlo."

During their sojourn in San Francisco, the Riveras received a visit from Wilhelm Valentiner, director of the Detroit Institute of Art, offering Rivera a commission for a mural in the garden court of the Institute. The couple moved to Detroit, where Kahlo was homesick and became tired of working all the time. She also found the United States to be boring compared with Mexico, and acted out her displeasure.

In Detroit, following a second abortion Frida Kahlo began to forge her unmistakable iconography. She was barely two months pregnant, and Rivera again did not want a child. Frida took quinine to abort, but it did not happen right away. On July 4, 1932, Frida lost the pregnancy and out of this she produced the lithograph *Frida and the Abortion* (1932). The edition was never pulled and only twelve proof copies were made. In the image, a nude Frida Kahlo stands suspended in mid air; to her left, cell division turns into a fetus, a male, attached by an umbilical cord that cir-

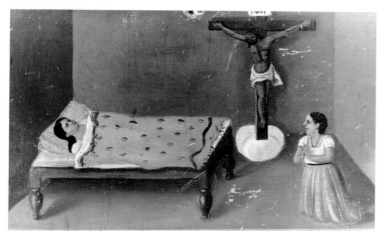

cles Kahlo's leg climbing to her navel. In her abdomen nests a smaller, less developed pregnancy. To her left, plants in the forms of male and female genitalia grow nurtured by a fluid that spills from her body. A tearful and paralyzed Kahlo is observed by the moon, which also cries for her. Frida Kahlo's left arm is drawn twice; one of the two arms holds Rivera's heart-shaped palette. Frida wears pre-Hispanic beads around her neck, and on her head the hairnet she wore in the surgical room where the abortion was performed.

Henry Ford Hospital (1932) was painted after the lithograph was created. Once more a nude Frida Kahlo, abdomen swollen by the pregnancy, lies on bloody sheets on a bed suspended in the forefront of the painting against the cityscape of Detroit. Her left hand holds six ribbons, each one of which is linked up to one aspect of the abortion. In the upper left is a dummy used in the obstetrician's office to demonstrate how a fetus grows in the uterus; in the middle top, an unborn male fetus; in the upper right corner, a snail to suggest the slow progression of gestation; in the lower left, the escape valve of an autoclave to suggest how the increased pressure forced her uterus to burst open; in the lower middle, a purple orchid that Rivera brought her in the hospital; and in the lower right, a view of her pelvis, rotated and malformed initially by her childhood polio.

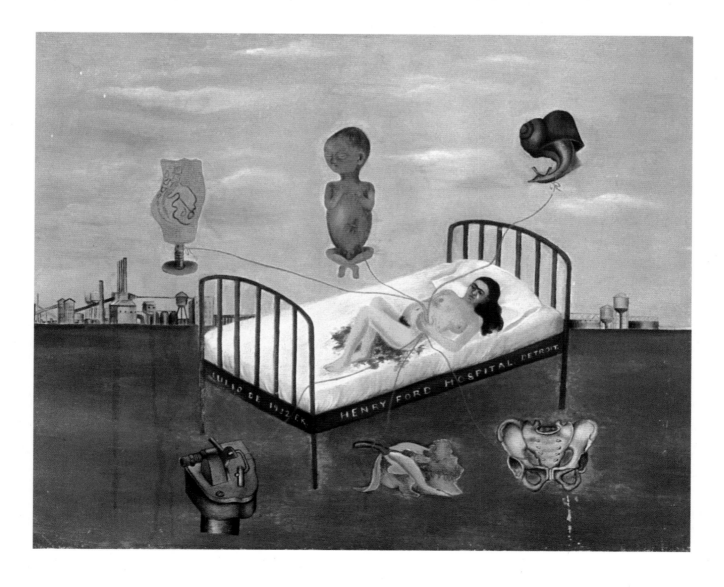

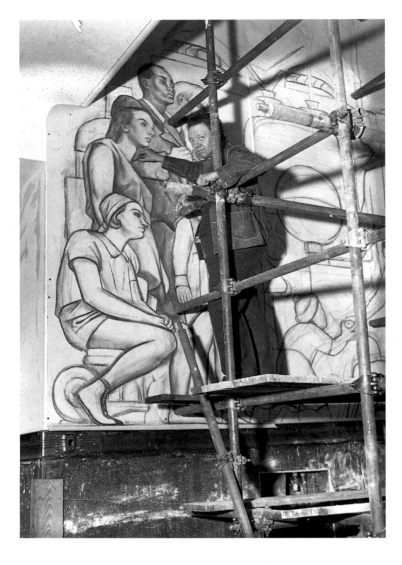

On September 15, 1932, Kahlo's mother, who suffered from breast cancer and had just undergone gall-bladder surgery two days earlier, died. Frida had traveled to Mexico with Lucienne Bloch, one of Diego's assistants in Detroit. She had arrived one week earlier but had not visited her mother nor would she see her body afterwards and she was not able to stop crying. Upon her return to Detroit, Frida Kahlo painted *My Birth*, with her mother dead and she, an abandoned newborn, in a world ruled by the Virgin of Sorrows.

The Riveras returned to Mexico in December 1933, eight months following Diego's dismissal from the unfinished Rockefeller project at the RCA building and one month before its destruction. Before his return to Mexico he had tried to repaint the mural for free, but no one provided the building. He settled for painting twenty-one movable panels for the New Workers School, his version of the history of the United States. While he was engaged with this project, he had an affair with the young sculptor Louise Nevelson.

Whenever Kahlo expressed boredom, Rivera had encouraged her to paint her life. He had suggested she wear Mexican costumes and jewelry and that she use the *retablo* format for her paintings. He knew that although she had her own personal strength she was essentially fragile. Frida Kahlo painted *Xóchitl, Flower of Life* (1938) in preparation for her solo exhibit at the Julien Levy Gallery in New York later that year. The image is that of a flower resembling female genitalia. In Náhuatl, the language of the Aztecs, *Xóchitl* means flower, but it also stands for "something fragile." Frida Kahlo nicknamed herself *Xóchitl*.

The Rivera's marriage was shaky, and Diego's withdrawal from Frida was internalized by her — the more he pulled away, the needier she became. Back in Mexico, he began an affair with Kahlo's younger sister, Cristina.

The Riveras separated for some time; there was talk of divorce and Kahlo took an overdose of barbiturates. She also had romantic liaisons with engraver Ignacio Aquirre and later with sculptor Isamu Noguchi. Broken-hearted, Kahlo recreated her sorrow in *A Few Small Nips* (1935), the portrait of a dead young woman butchered by her boyfriend, who claimed to have given her only a few small nips. It was her turn to pay Rivera back when Leon Trotsky came to Mexico as the Rivera's house guest in January 1937. In November of that year, Frida Kahlo had a liaison with Trotsky and painted for him a love token, the *Self-Portrait Dedicated to Leon Trotsky* (1937).

Rivera needed distance from Kahlo and found it in a visit from the surrealist André Breton, who had been invited to Mexico to present a series of lectures. He and his wife Jacqueline

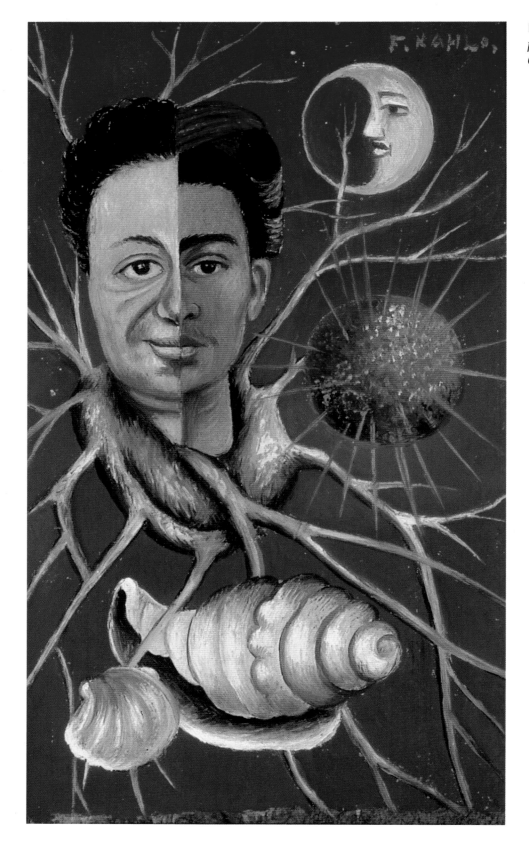

Lamba arrived in Mexico in April 1938. When Breton saw Kahlo's unfinished *What the Water Gave Me* (1938), the metaphorical self-portrait of what life had given her — floating on the water of her bathtub — he immediately labeled her an innate surrealist, and offered to show her work in Paris. Julien Levy had written her earlier proposing a show and Rivera pushed for it, claiming it would be good for her and her painting. She feared for their marriage. Both were right. A triumphant Kahlo returned from Paris to face Rivera's request for a divorce.

The Two Fridas (1939) was inspired by this jolting experience. The double self-portrait depicts two Frida Kahlos holding hands with each other, one deriving energy and love from an artery

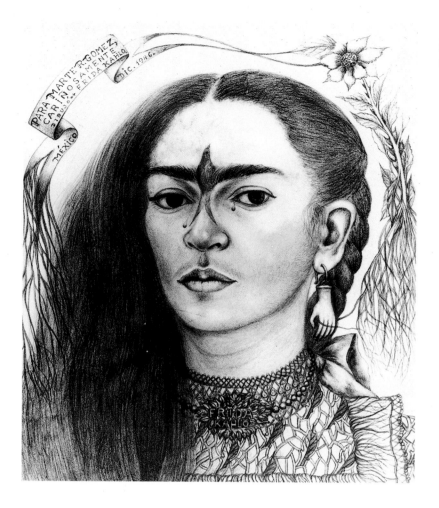

LEFT: *This self-portrait was done for Marte R. Gómez, Diego's main patron. The earrings she wears were given to her by Picasso during her stay in Paris in 1939.*

RIGHT: *When Kahlo painted her self-portraits, she used mirrors. For this reason her injured foot appears to be the left.*

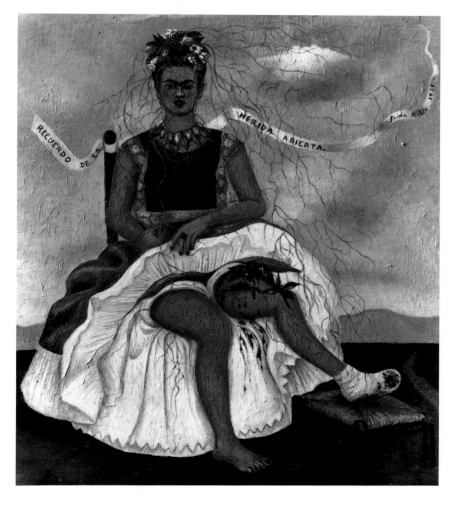

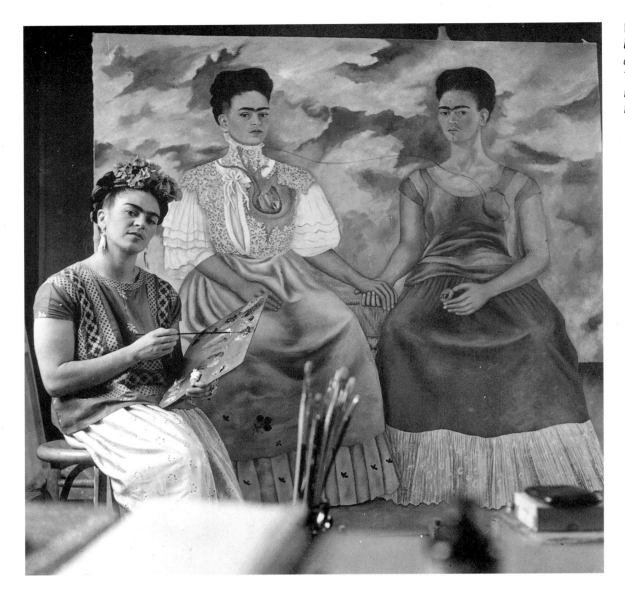

attached to Rivera's portrait in her left hand, the other losing blood from another artery because she is not loved by him. Rivera's rejection made Kahlo more open about her affairs, particularly with women. *Earth Herself or Two Nudes in a Jungle* (1939) portrays two nude women, the head of one in the lap of the other.

When the divorce was finalized, Frida painted her *Self-Portrait with Cropped Hair* (1940) in which she is dressed in an oversized man's suit, with her braids cropped and her hair styled like a man's. Above the image she included the lines of a popular song, "Look, if I loved you it was because of your hair; now that you're bald, I don't love you anymore."

Throughout her works, Christian imagery remained one of Frida Kahlo's consistent iconographic references despite her claimed atheism. Ella Wolfe, her friend and confidante, believed Kahlo was attracted by the imagery itself rather than by its religious meaning. During the year of the Riveras' divorce Kahlo

turned thirty-three, the same age as Christ when he was crucified. Kahlo identified with elements of the Passion and Christ's betrayal and personalized them. In her monumental painting *The Wounded Table* (1940), Kahlo sits behind a stripped pine table, its knots bleeding and its legs — human legs — flayed. To her right is a papier mâché Judas effigy, similar to one that stood by Rivera's easel. The effigy's hands on the table recall Luke's memory of Christ's words during the Last Supper, "but behold the hand of him that betrayeth me is with me on the table." (Luke, 22:21) To Kahlo's left is the figure of a pre-Hispanic funerary couple from Ixtlán del Rio, one of its arms connected to one of Kahlo's; farther to the left is a skeleton made of clay and springs smiling a sardonic smile, pulling at Kahlo's hair just as scourgers did when they tortured Christ, bound at the column. On one extreme are Kahlo's nephew Antonio and niece Isolda, her sister Cristina's children; to the other extreme is Kahlo's pet fawn, Granizo. She probably

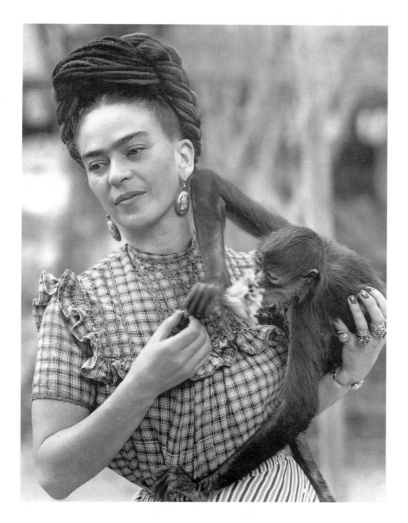

included the children and the fawn because in one of the Eleusinian mysteries children and fawns were sacrificed and flayed, and their skins worn by the participants.

In the *Self-Portrait with Thorn Necklace and Hummingbird* (1940) Kahlo paints herself in a frontal pose to enhance the immediacy of her presence. She has unraveled Christ's crown of thorns and wears it as a necklace that digs into her flesh. Around her hair, butterflies represent the Resurrection. Over her left shoulder the black cat stands for bad luck and death; over her right shoulder the monkey represents the devil — the baser forces in life.

Kahlo and Rivera remarried in San Francisco on December 8, 1940, on Rivera's 54th birthday, with the encouragement of their friend Dr. Eloesser. But their interpersonal daily life changed very little. Both continued to paint and have affairs. What did change significantly was Kahlo's art, which attained a heightened maturity. By now her work was selling well and with regularity through two galleries and friends. She liked the independence from Rivera that money brought her.

The following year she painted *Self-Portrait with Bonito* (1941), following the death of her father. A sad looking Kahlo,

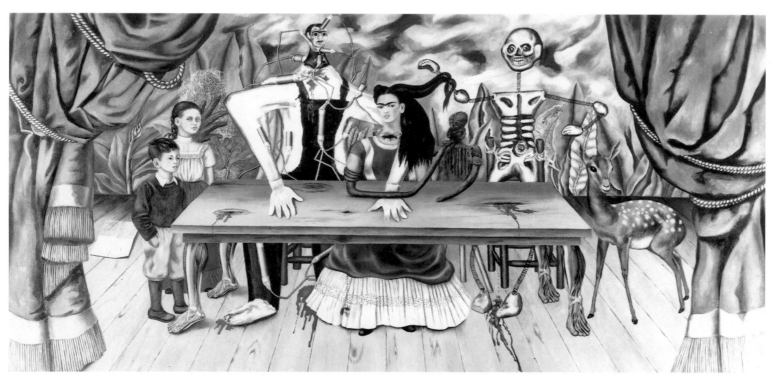

TOP: *Frida with her pet spider monkey, Caimito de Guayabal, in 1944.*

ABOVE: *Frida painted herself in* The Wounded Table *as Christ to "tell" the world that Rivera had betrayed her. She modeled the image after Leonardo da Vinci's* Last Supper.

cate several discs, putting pressure on blood vessels and nerve endings. The result would be diminished blood flow to the right leg, making it more vulnerable to trophic ulcers, and the gangrenous state that preceded its amputation.

In *The Broken Column* (1944) Frida Kahlo painted a symbol of her physical and emotional life. For this self-portrait, she used as a point of departure traditional images of Christ at the column. In traditional images, Christ appears nude except for a loincloth, bound to the object of His humiliation, the column. Frida Kahlo portrays herself nude except for a cloth that wraps around her hips. The center of her chest, cracked open, reveals the object of her humiliation, a piece of ionic column. Holding her up, a polio corset alludes to the first injury her spinal column received. The following year, Kahlo created *Without Hope* (1945) in which she portrays herself bedridden in a dry, rocky vale. The easel which

ABOVE: *Frida began* Diego in my Thoughts *in August of 1940, the year she and Diego were divorced. She finished it three years later.*

dressed in mourning, is framed by the leaves of a rubber plant which serve as a prop in the drama played out by the insects in an interrupted cycle in the life of a butterfly.

Despite her success in her career, one thing that did not improve was Kahlo's health. The effects of polio had shortened her right leg and further damage had been done because she never wore an orthopedic shoe or brace. Kahlo chose regular shoes instead and walked about as if the injury could be overlooked. Unfortunately, it could not, and her condition worsened little by little. Initially her pelvis rotated out, creating an impediment to a vaginal delivery, should Kahlo have decided to allow her pregnancies to progress to term. Later, her spinal column would become scoliotic; this curvature of the spine would dislo-

ABOVE: *Frida after her father's death in 1941.*

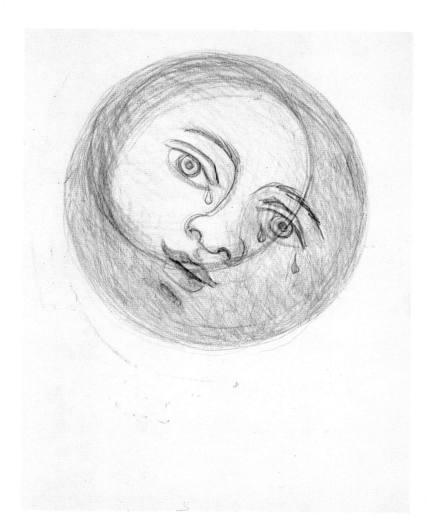

LEFT: *This tearful moon is a preparatory sketch for the painting* Moses *(1945).*

BELOW: *Frida on her patio, after being released from the British Hospital in Mexico after a one year stay from 1950–51.*

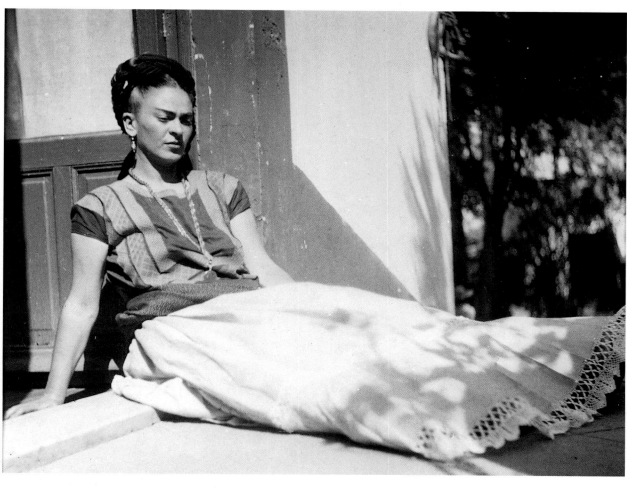

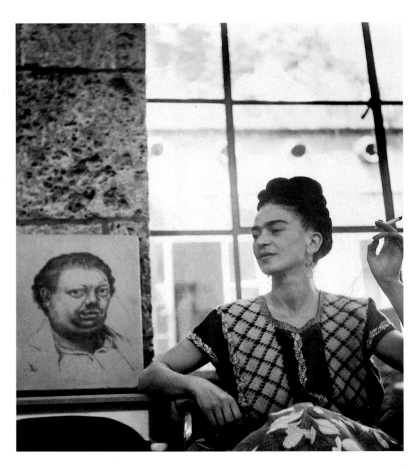

LEFT: *A much thinner Frida in her studio by Diego's self-portrait lithograph, probably taken in 1953 prior to the amputation of her right leg.*

BELOW: *Repeated betrayals gave rise to this image of destruction; Kahlo dedicated it to Rivera who nevertheless remained an unabashed philanderer.*

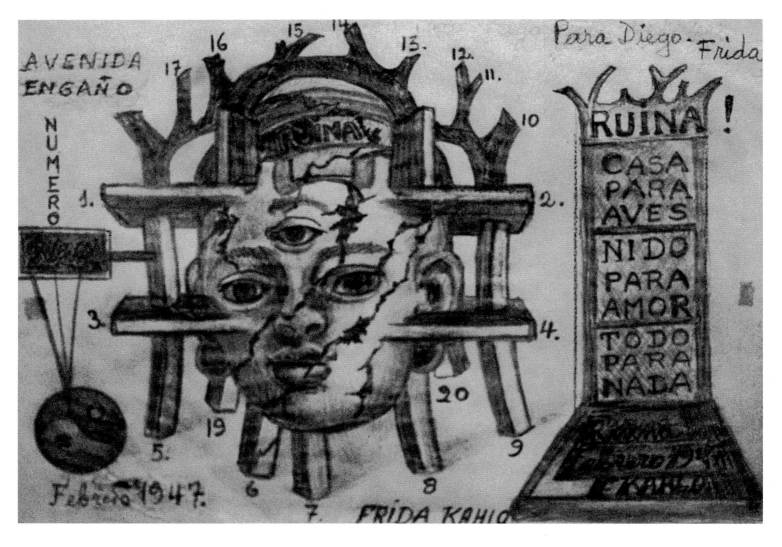

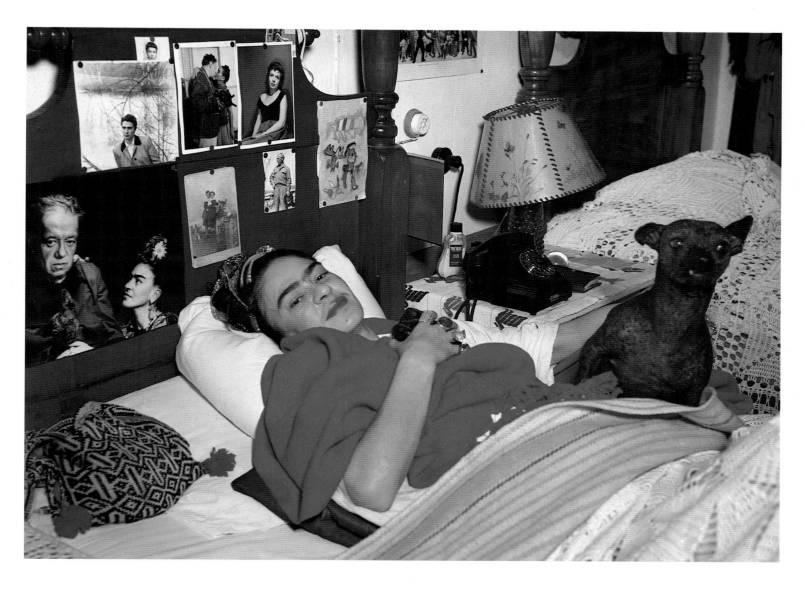

ABOVE: *Frida in bed with her favorite Aztec hairless dog, Señor Xólotl.*

RIGHT: *Frida on her death bed in 1954.*

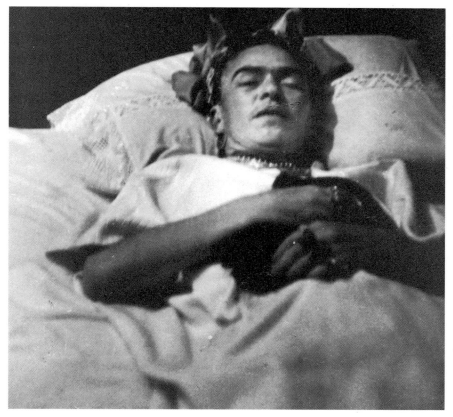

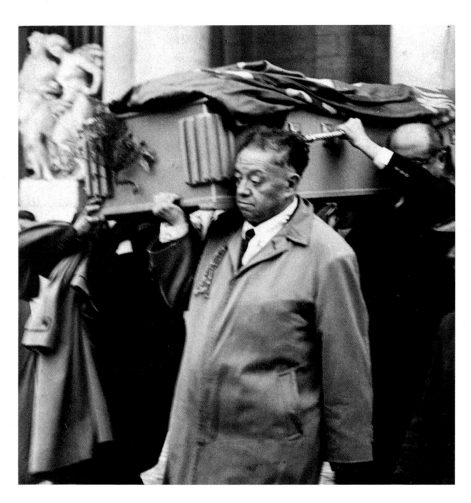

LEFT: *Diego Rivera as pallbearer at Frida Kahlo's funeral.*

BELOW: *Before her body was cremated, it lay in state at Mexico's prestigious Palace of Fine Arts. Frida's disciple Arturo García Bustos covered the coffin with the Communist flag. Rivera refused to remove it despite having promised Andrés Iduarte, Director of the National Institute of Fine Arts there would be no political demonstrations. Iduarte lost his directorship because he allowed this to take place.*

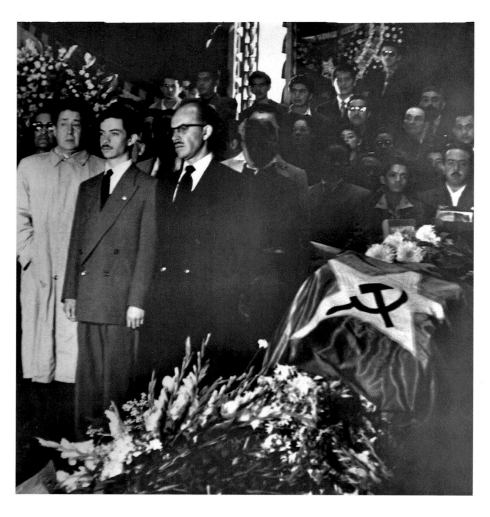

THE PLATES

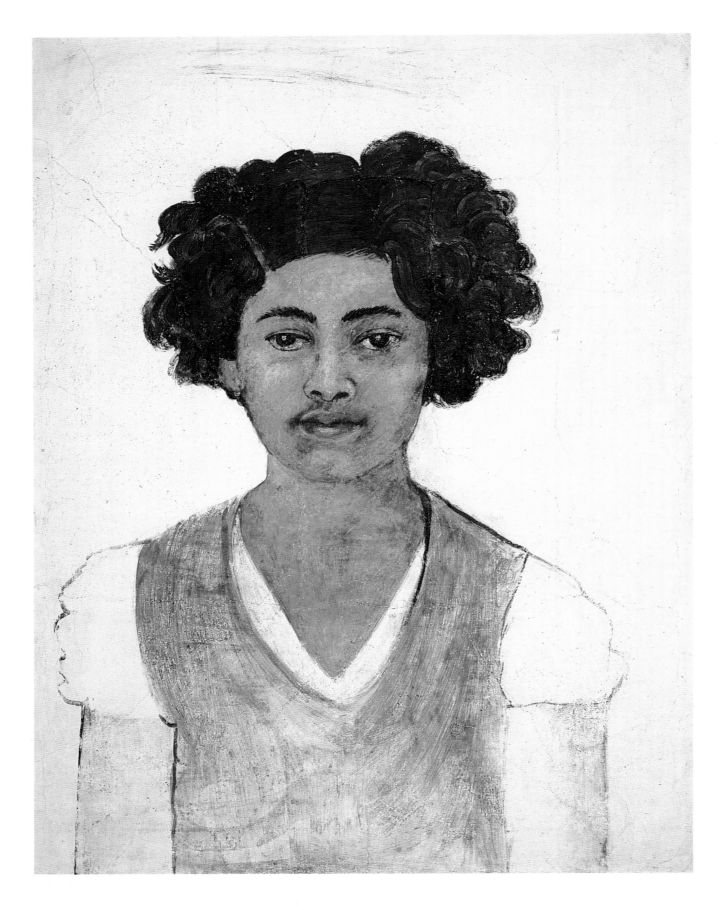

Self-Portrait, c. 1922
Fresco on plaster wall, 27 7/8 x 19 in.
Private Collection

RIGHT
Self-Portrait with Velvet Dress, 1926
Oil on canvas, 30 3/4 x 24 in.
Private Collection

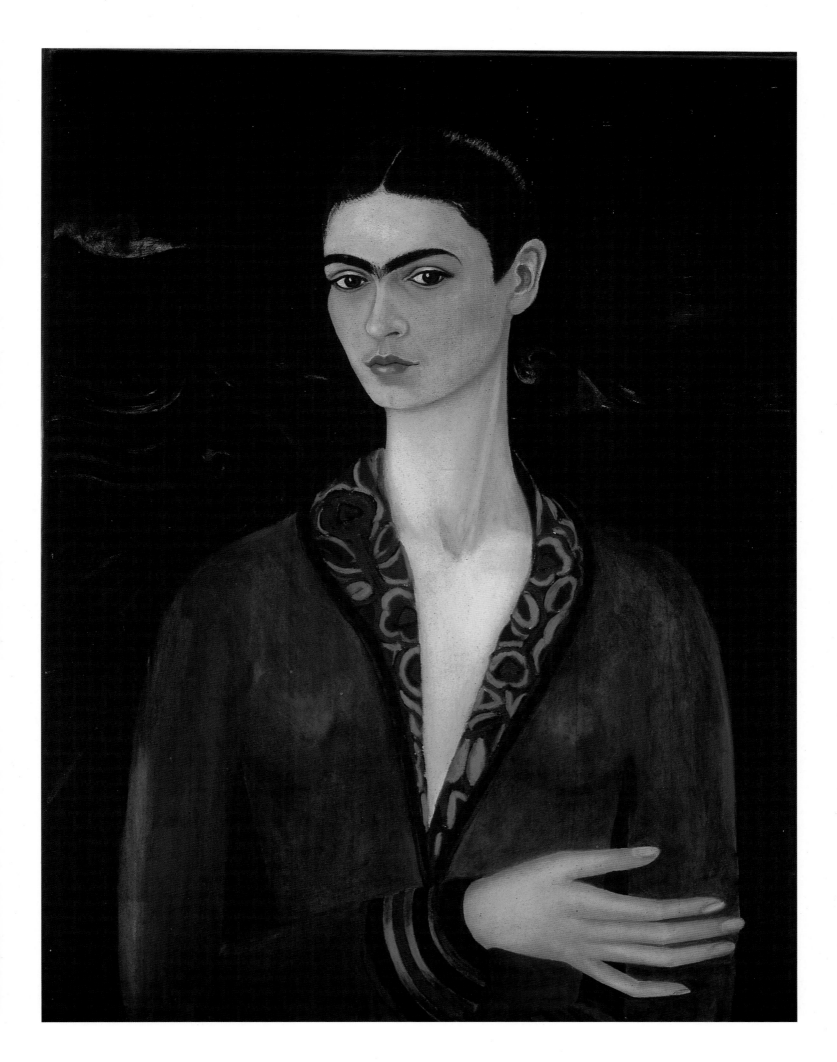

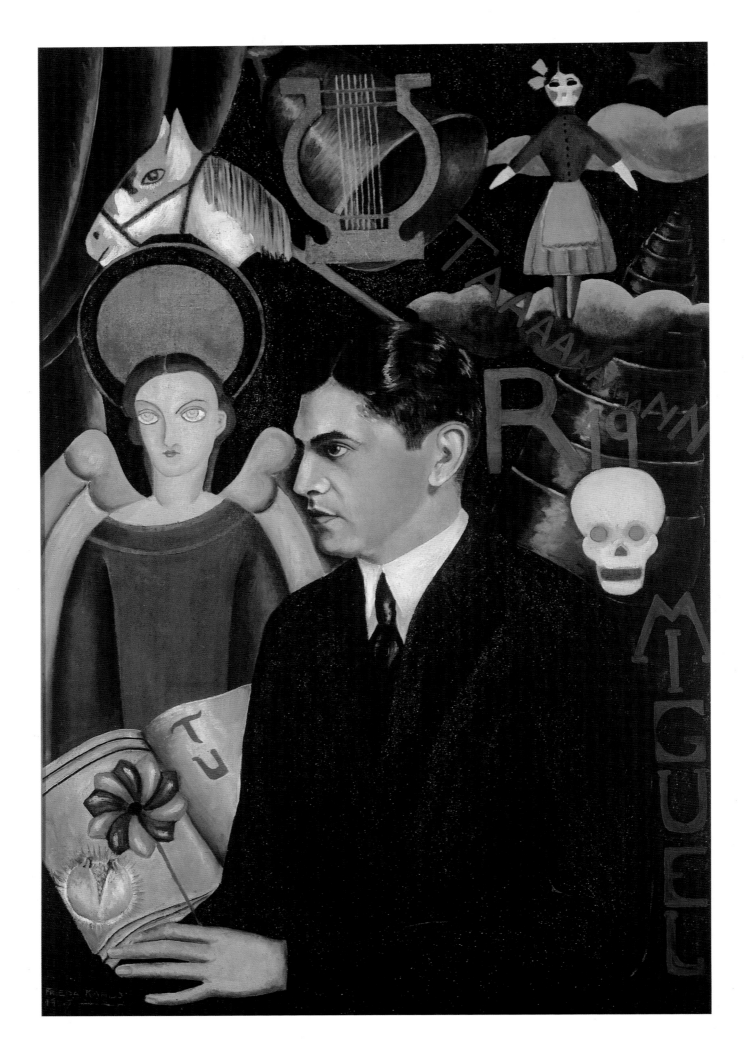

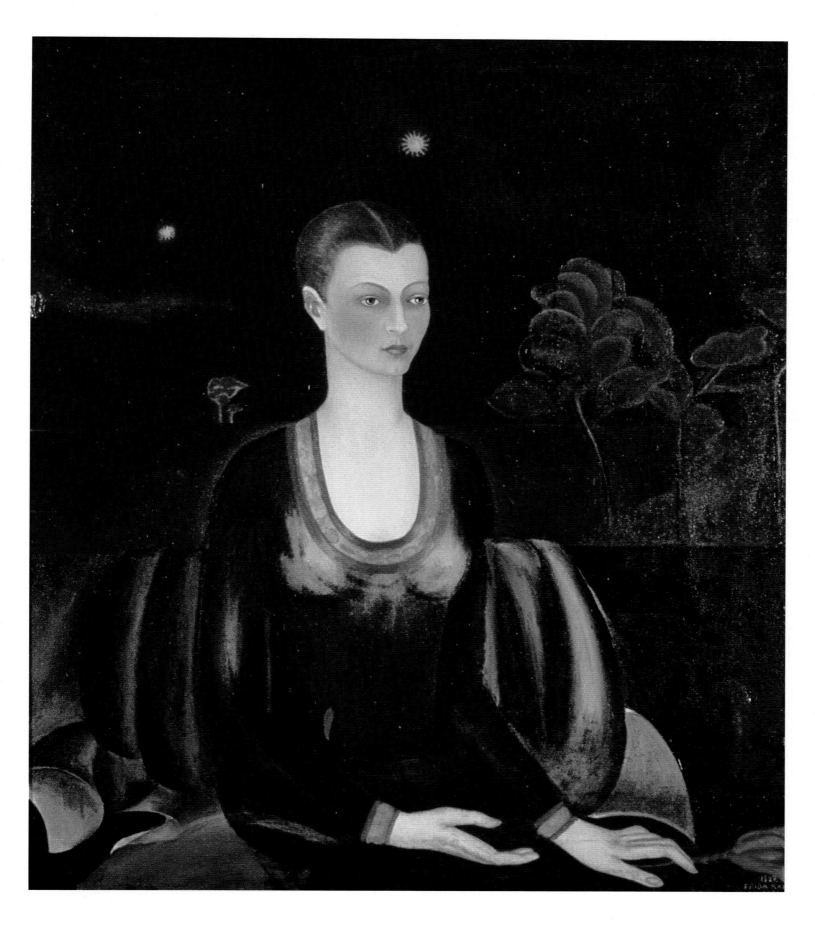

LEFT
Portrait of Miguel N. Lira, 1927
Oil on canvas, 42 ⅛ × 38 ⅞ in.
Instituto Tlaxcalteca de Cultura, Tlaxcala, Mexico

ABOVE
Portrait of Alicia Galant, 1927
Oil on canvas, 38 ¼ × 33 in.
Dolores Olmedo Foundation, Mexico City

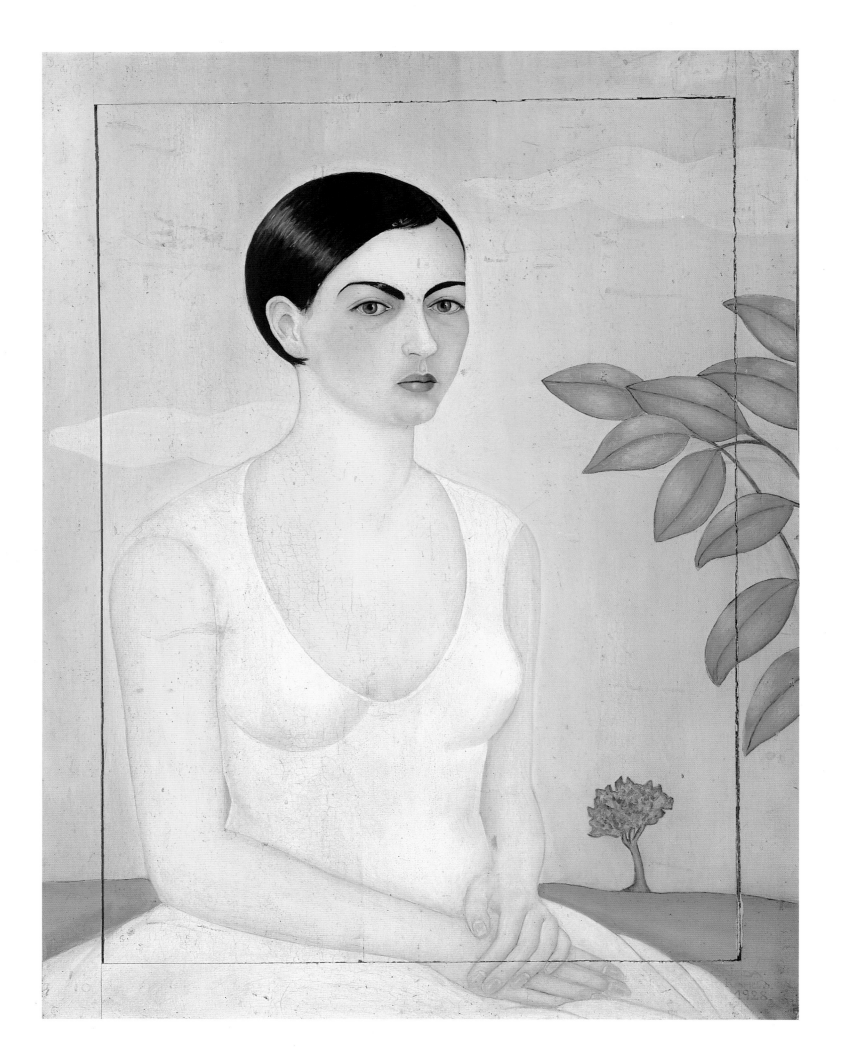

44

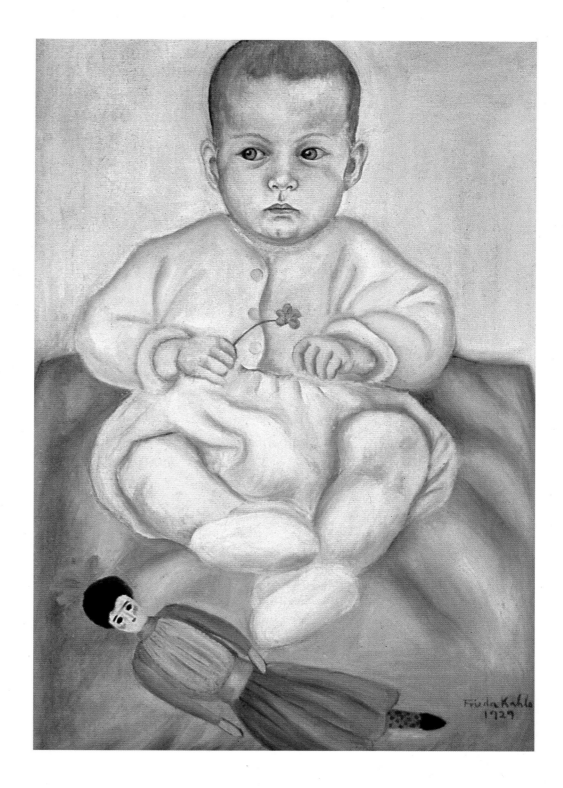

Isolda in Diapers, 1929
Oil on canvas, 25 3/4 x 17 1/4 in.
Seguros America Banamex, Mexico

Portrait of Cristina Kahlo, 1928
Oil on wood panel, 31 1/8 x 25 5/8 in.
Private Collection

45

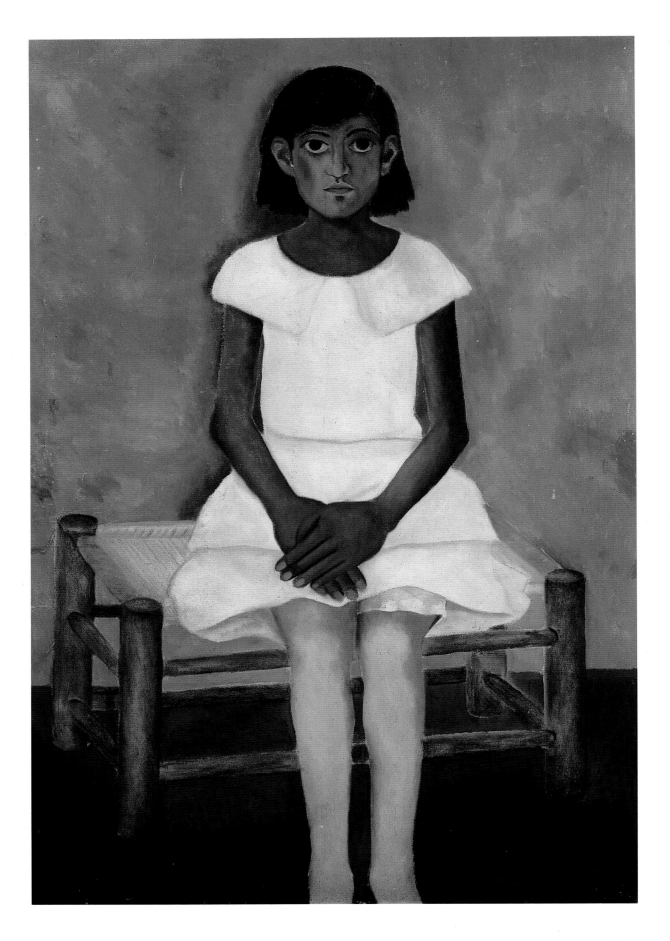

Portrait of a Girl, c. 1929
Oil on canvas, 46 ½ x 31 ½ in.
Frida Kahlo Museum, Mexico City

Portrait of a Woman in White, c. 1929
Oil on canvas, 46.8 x 31.8 in.
Private Collection, Europe

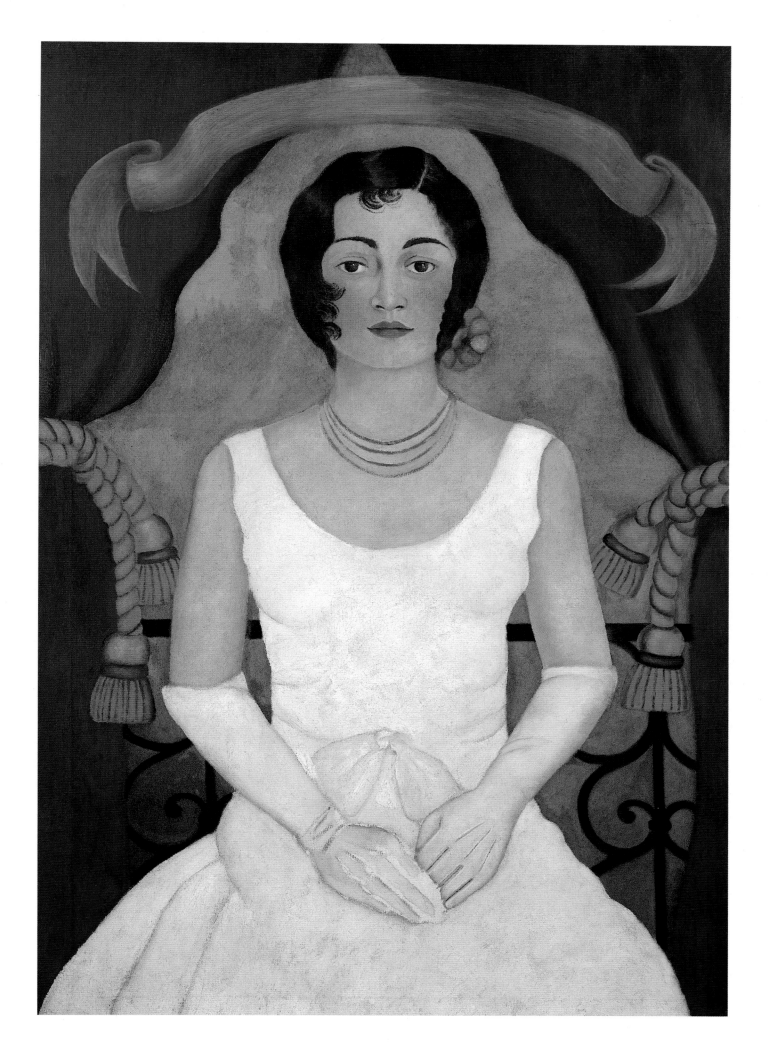

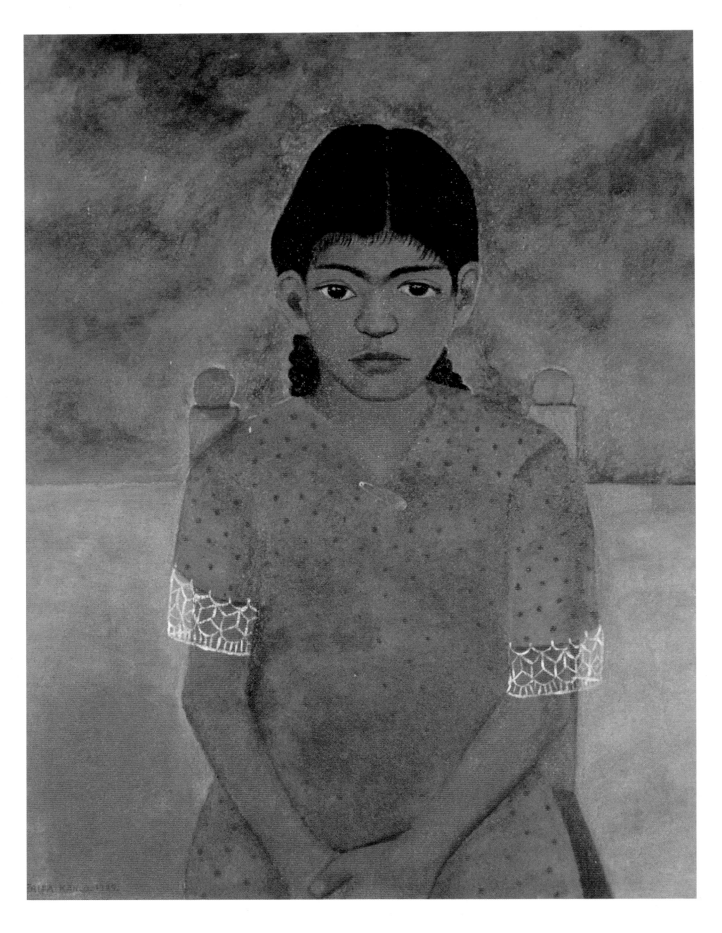

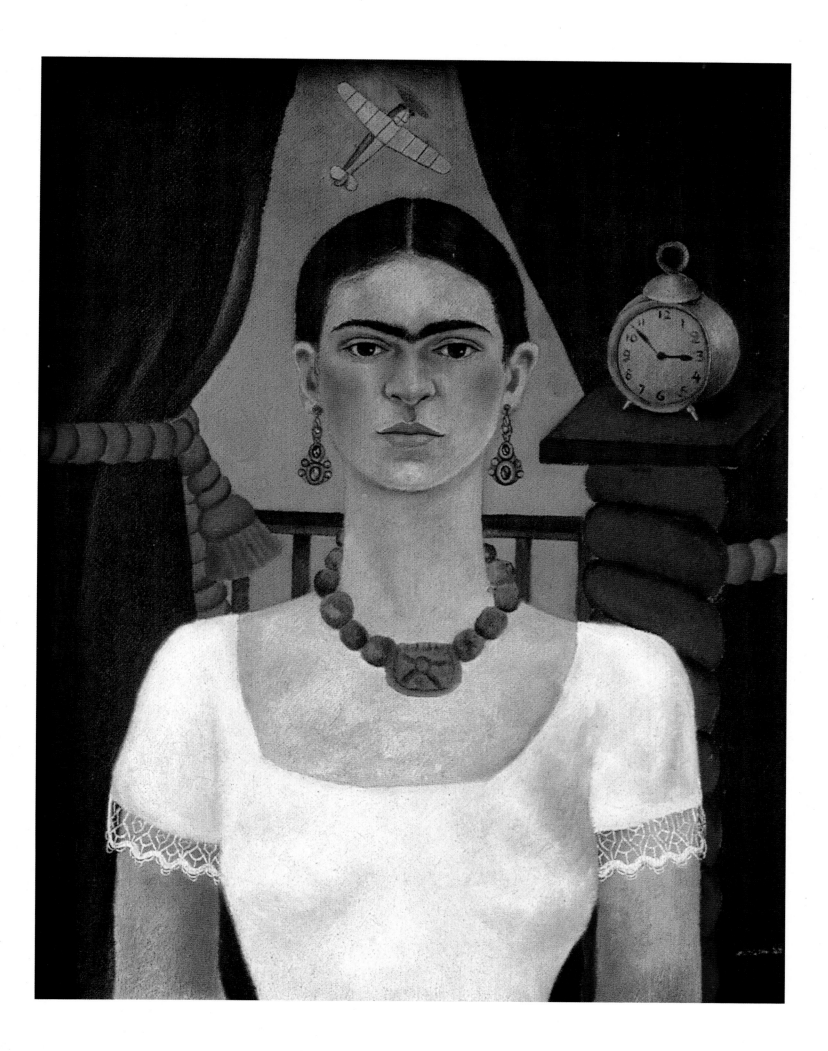

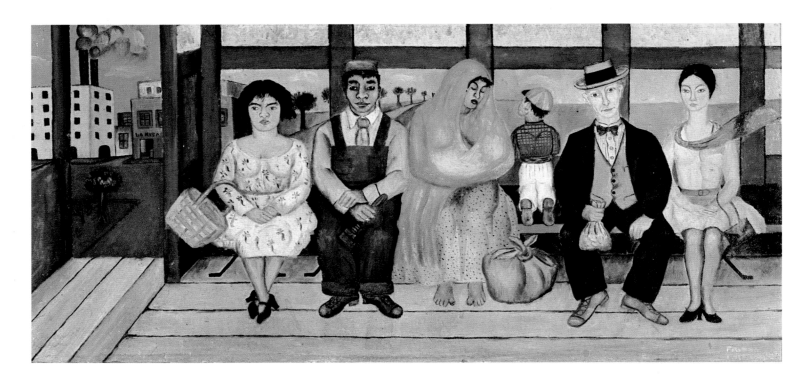

ABOVE
The Bus, 1929
Oil on canvas, 10 ½ x 22 in.
Dolores Olmedo Foundation, Mexico City

RIGHT
Two Women, 1929
Oil on canvas, 27 ⅜ x 27 in.
Private Collection, USA
Photo courtesy of Mary-Anne Martin/Fine Art, New York, NY

50

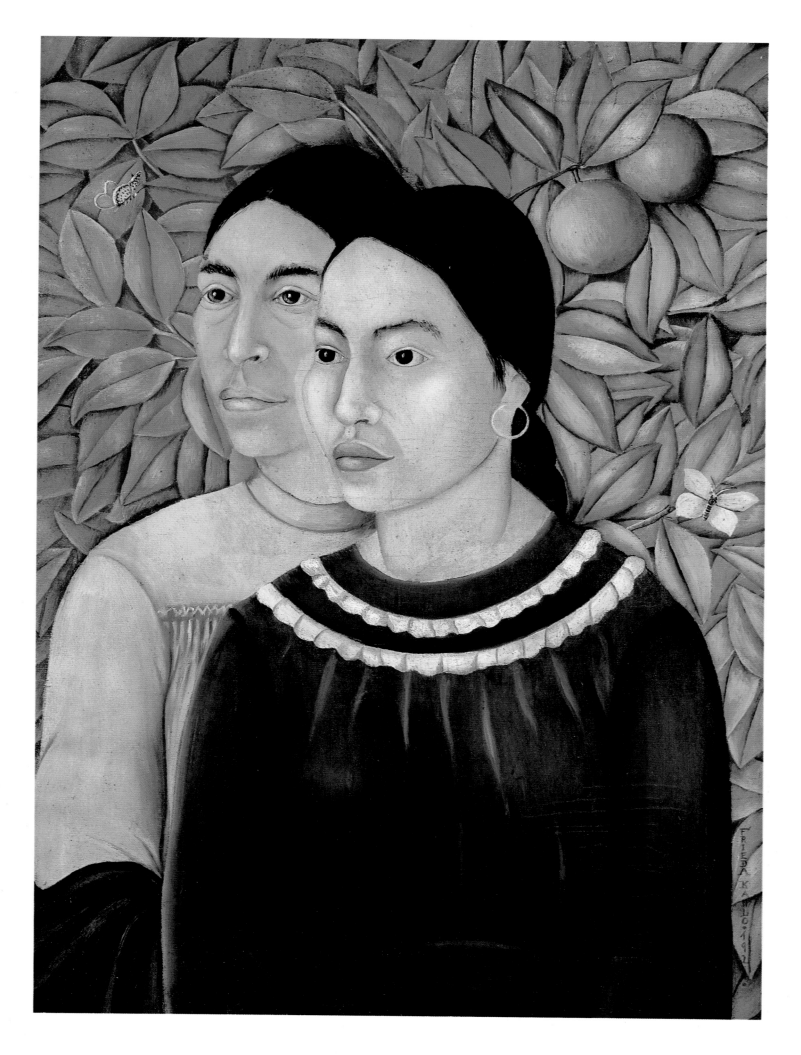

51

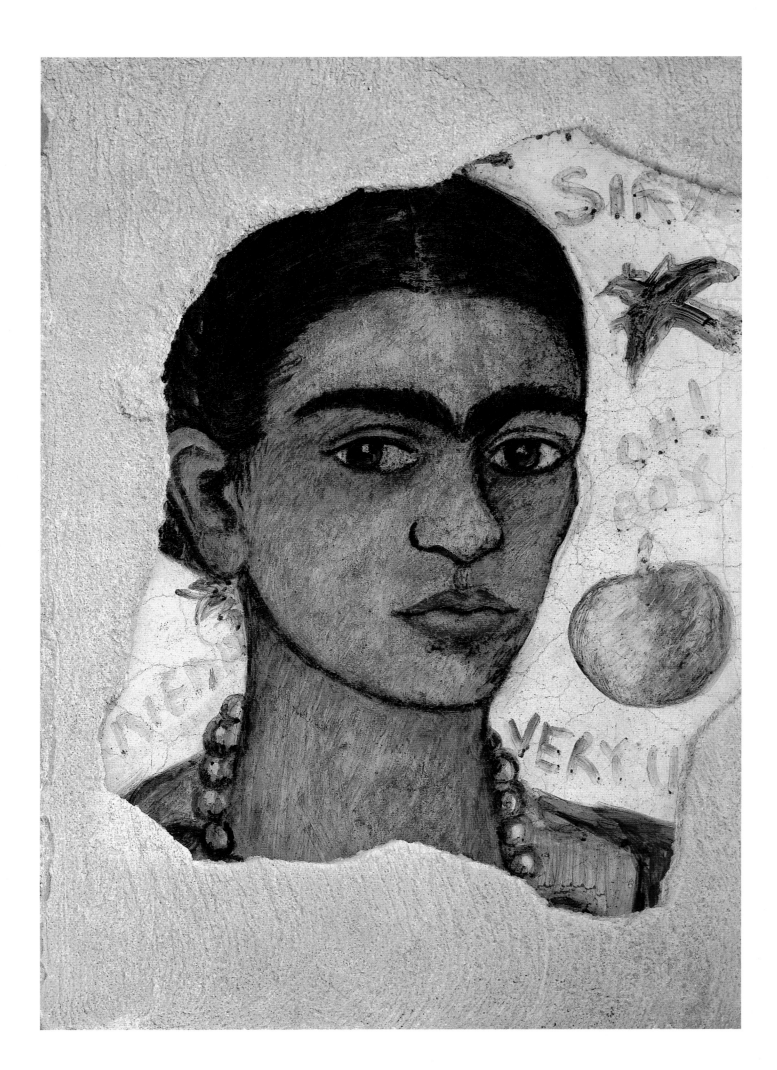

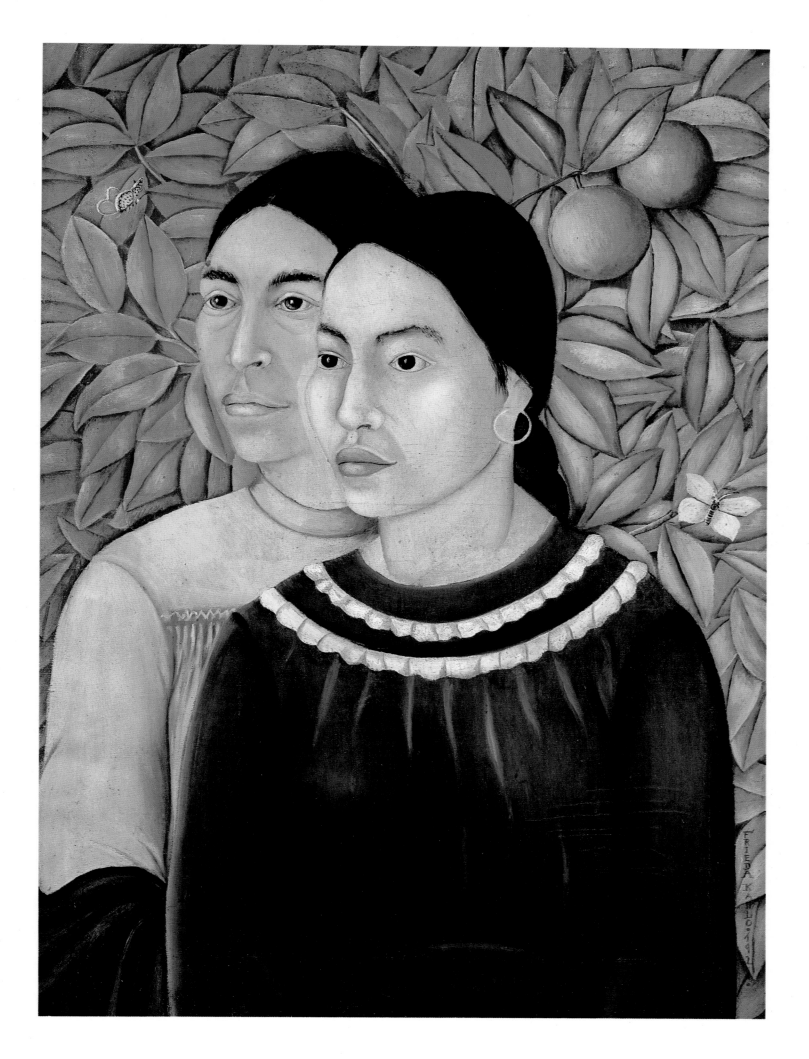

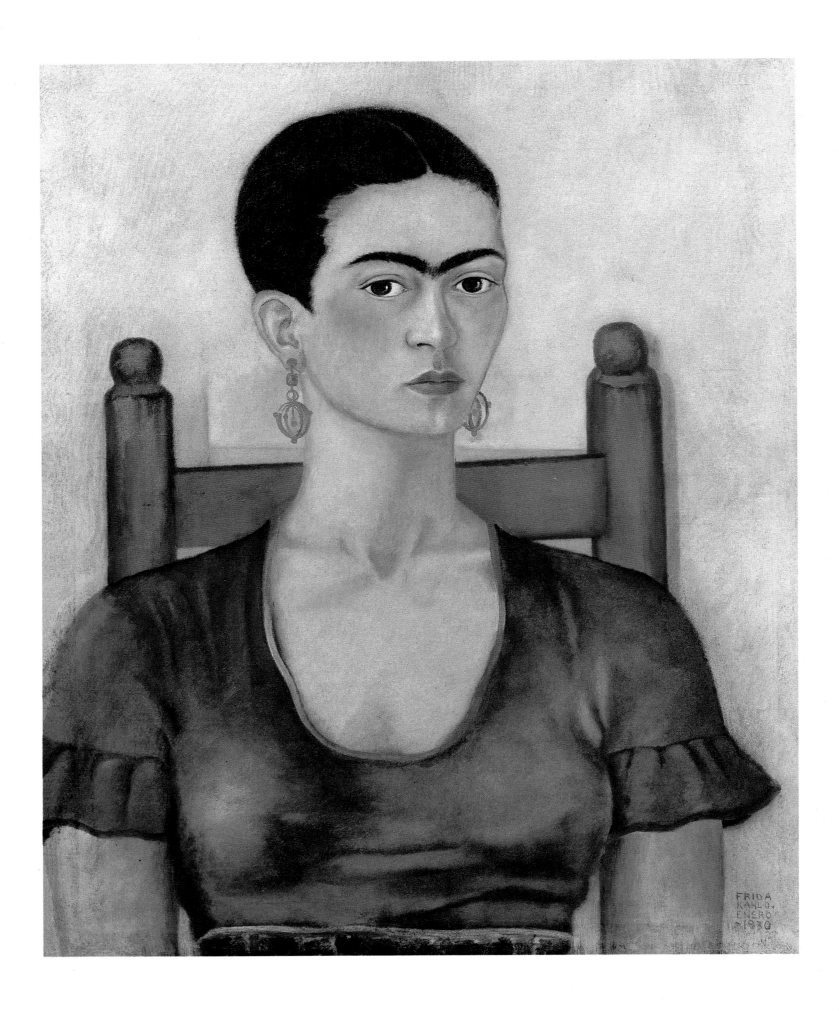

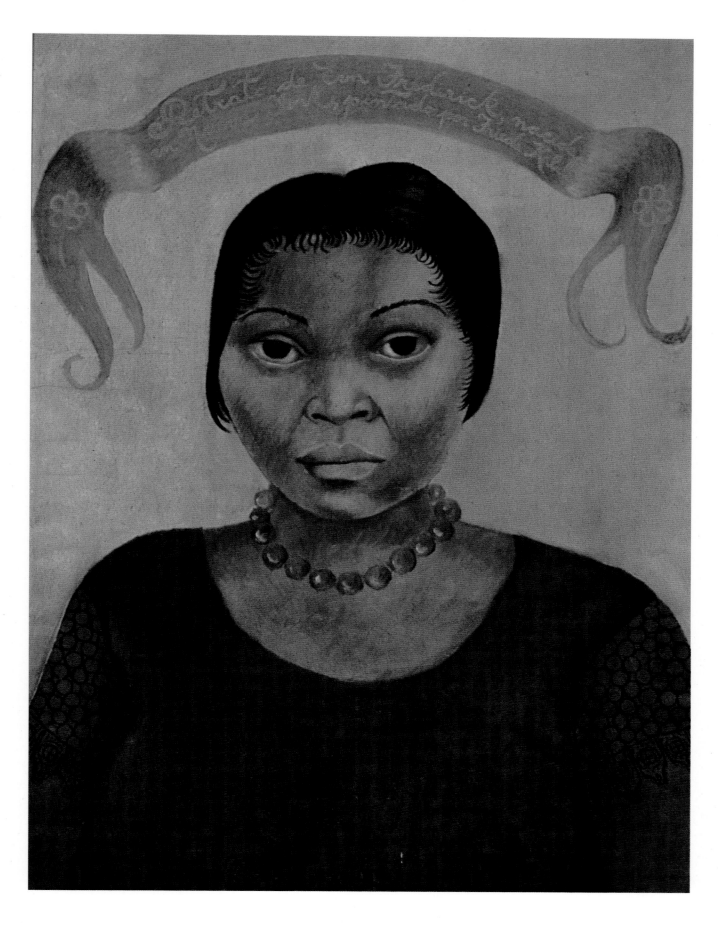

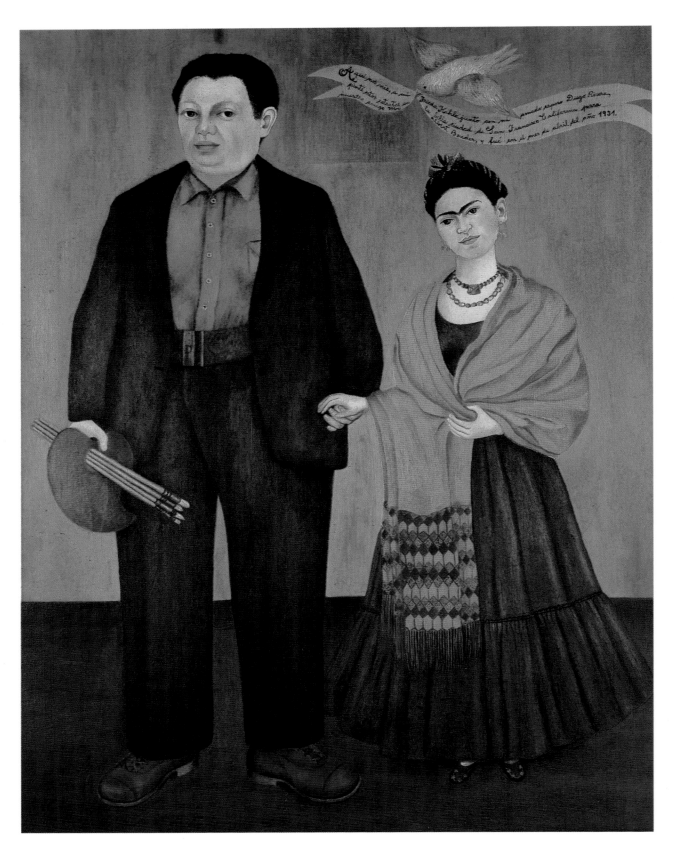

ABOVE
Frieda and Diego Rivera, 1931
Oil on canvas, 39 3/8 x 31 in.
Gift of Albert M. Bender
Albert M. Bender Collection
San Francisco Museum of Modern Art, CA

RIGHT
Portrait of Dr. Leo Eloesser, 1931
Oil on masonite, 33 1/2 x 23 1/2 in.
University of California, San Francisco School of Medicine

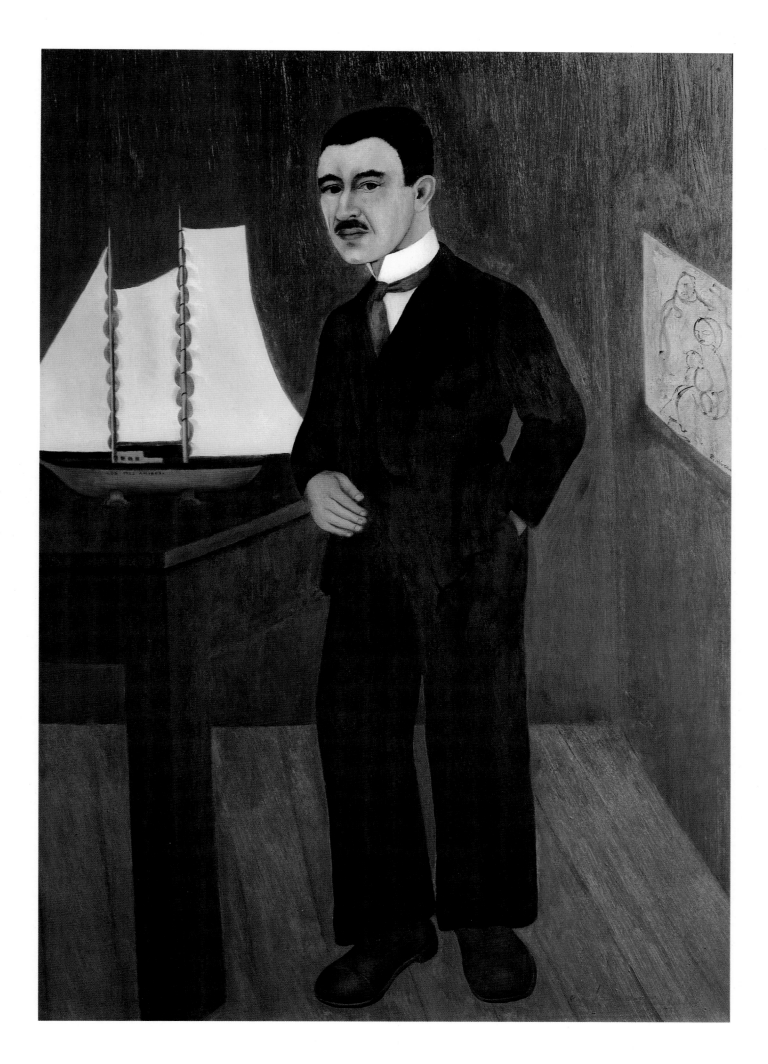

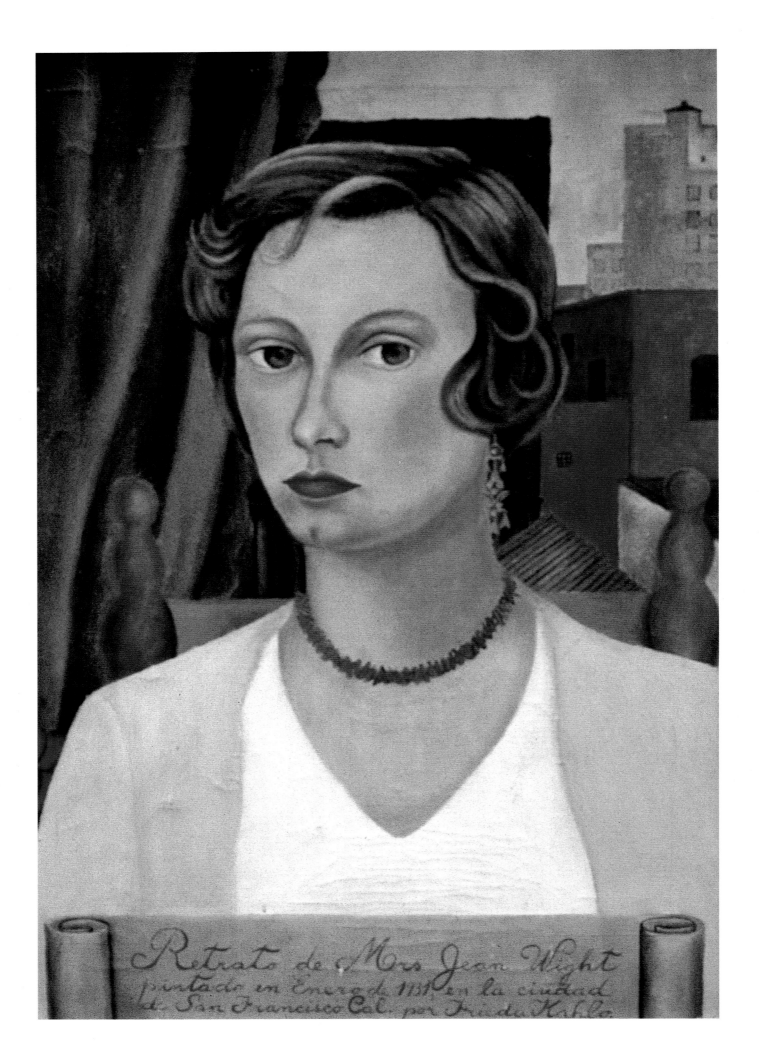

Retrato de Mrs Jean Wight
pintado en Enero de 1931 en la ciudad
d. San Francisco Cal. por Frieda Kahlo

LEFT
Portrait of Mrs. Jean Wight, 1931
Oil on canvas, 24 ⅞ x 18 ⅛ in.
Collection of Mr. and Mrs. John Berggruen

ABOVE
Self-Portrait Very Angry, 1932
Pencil on board, 11 x 8 in.
Private Collection, USA

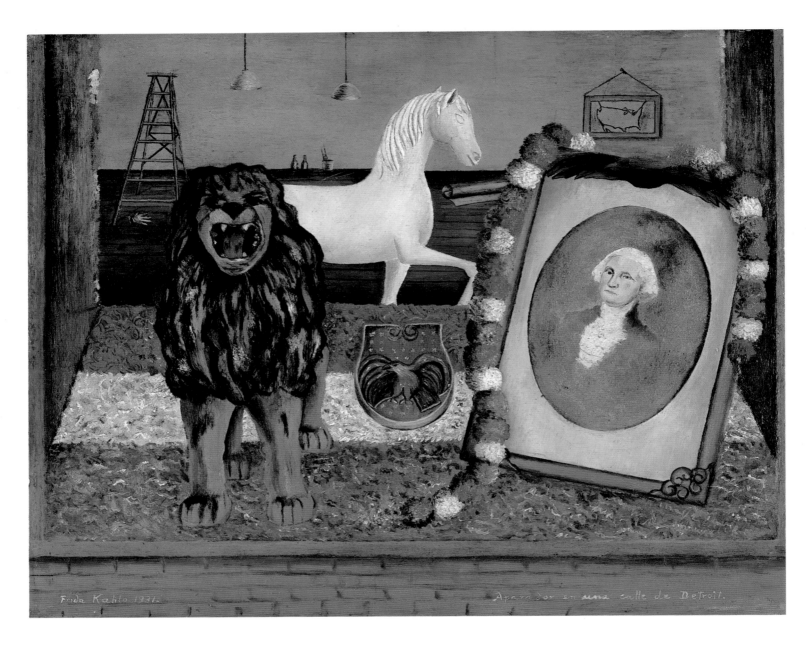

Window Display in Detroit, 1932
Oil on sheet metal, 12 ¼ × 15 in.
Private Collection

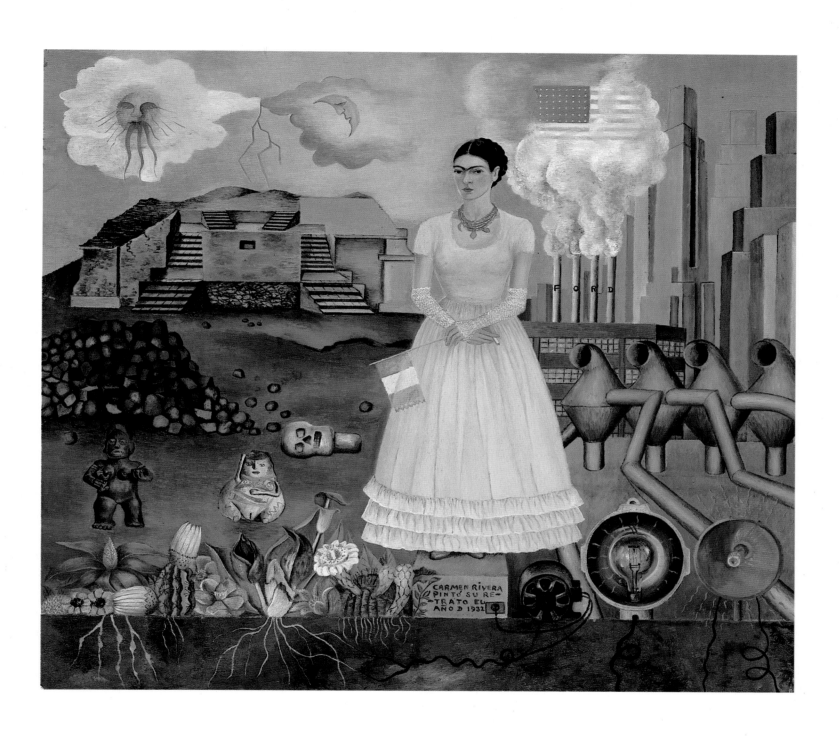

Self-Portrait on the Borderline Between Mexico and the United States, 1932
Oil on sheet metal, 12 ¹⁄₂ x 13 ³⁄₄ in.
Collection of Mr. and Mrs. Manuel Reyero, New York

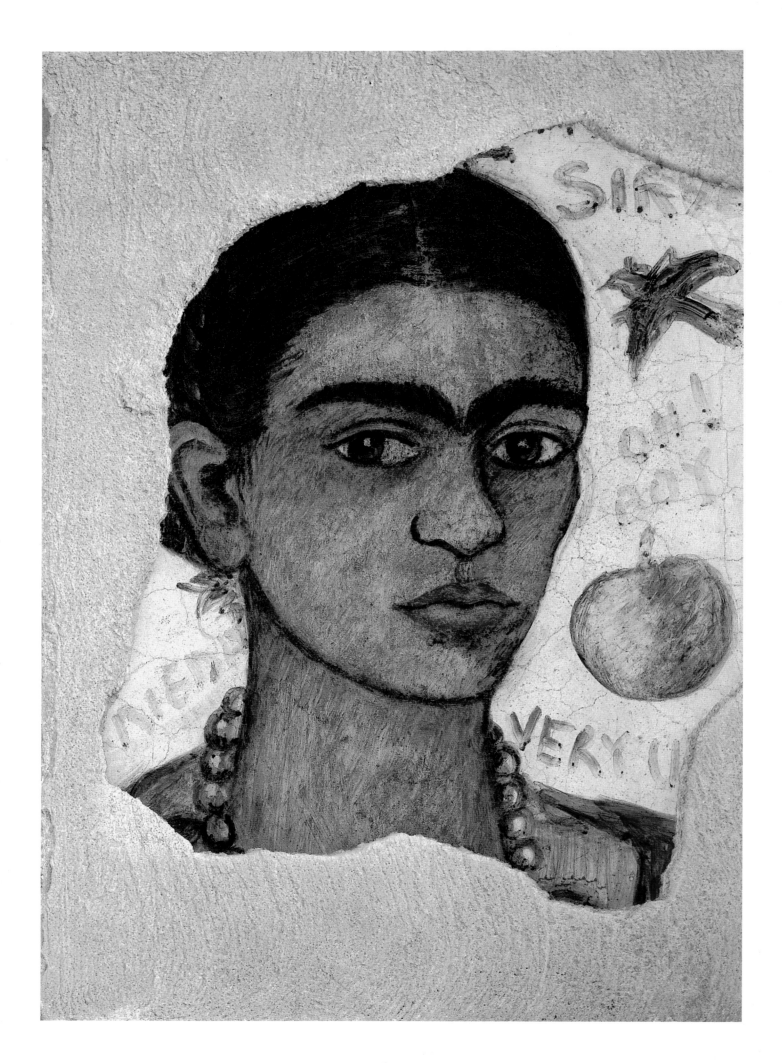

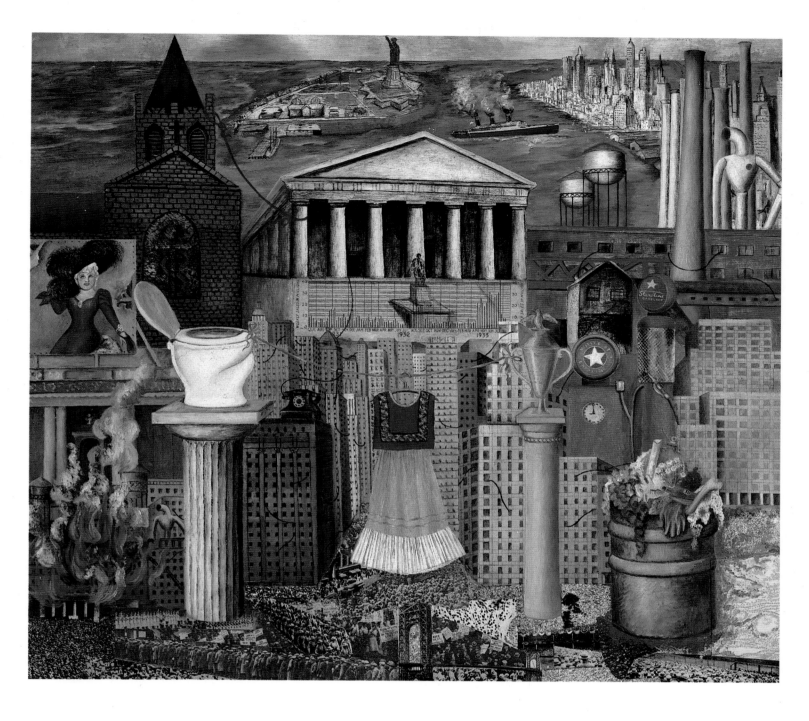

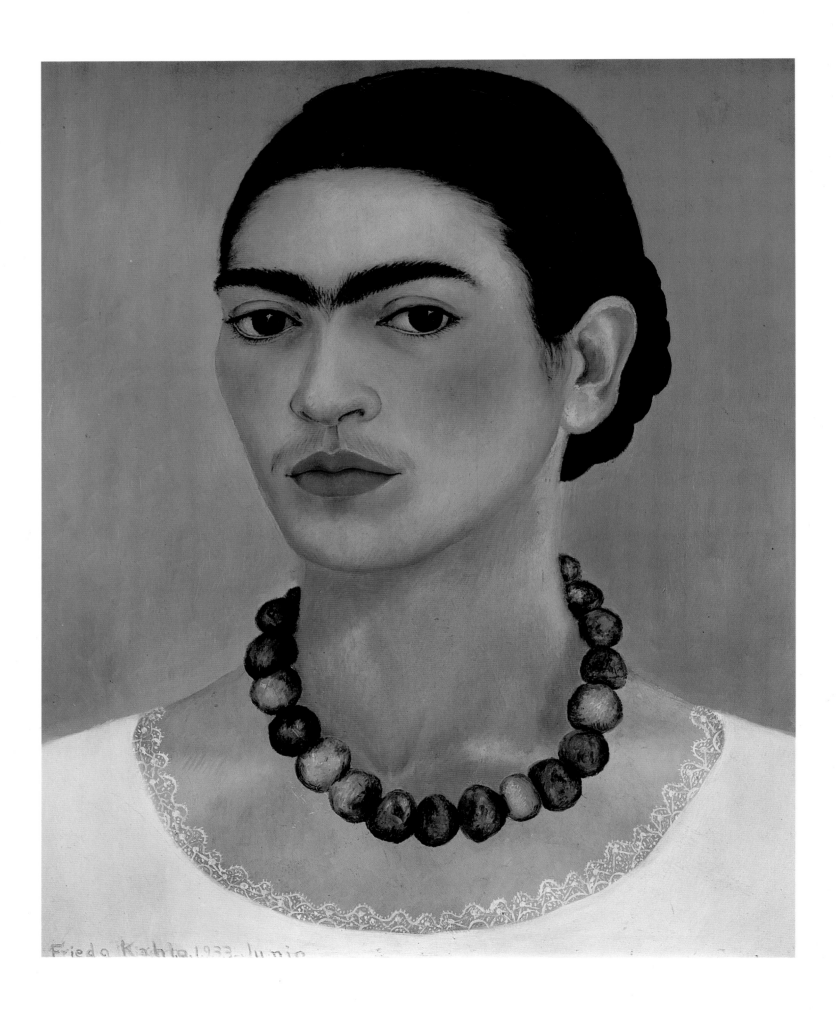

Frieda Kahlo. 1933. Junio

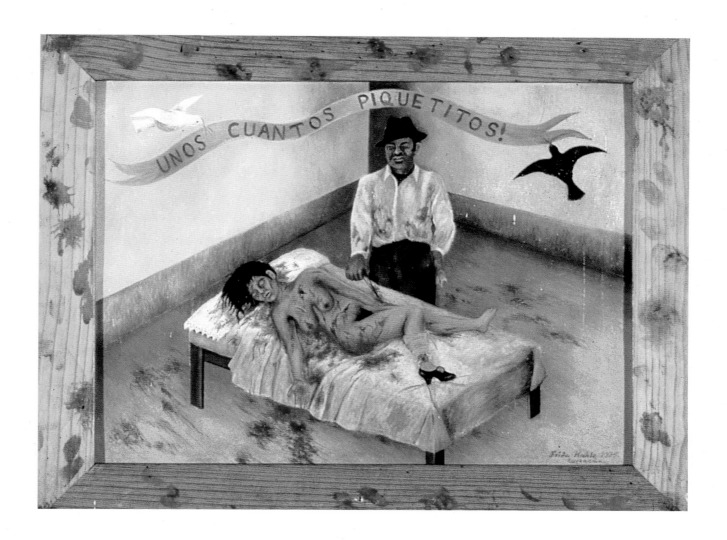

ABOVE
A Few Small Nips, 1935
Oil on sheet metal, 15 x 19 in.
Dolores Olmedo Foundation, Mexico City

LEFT
Self-Portrait with Necklace, 1933
Oil on sheet metal, 13 ½ x 11 ½ in.
Jacques and Natasha Gelman Collection, Mexico City

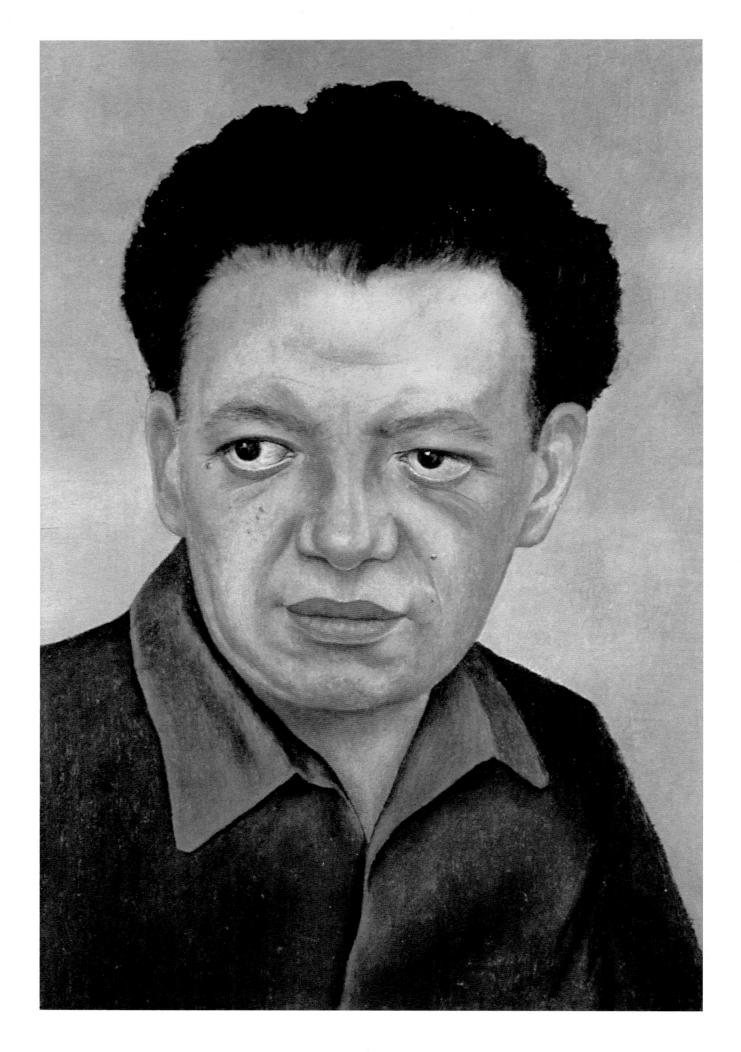

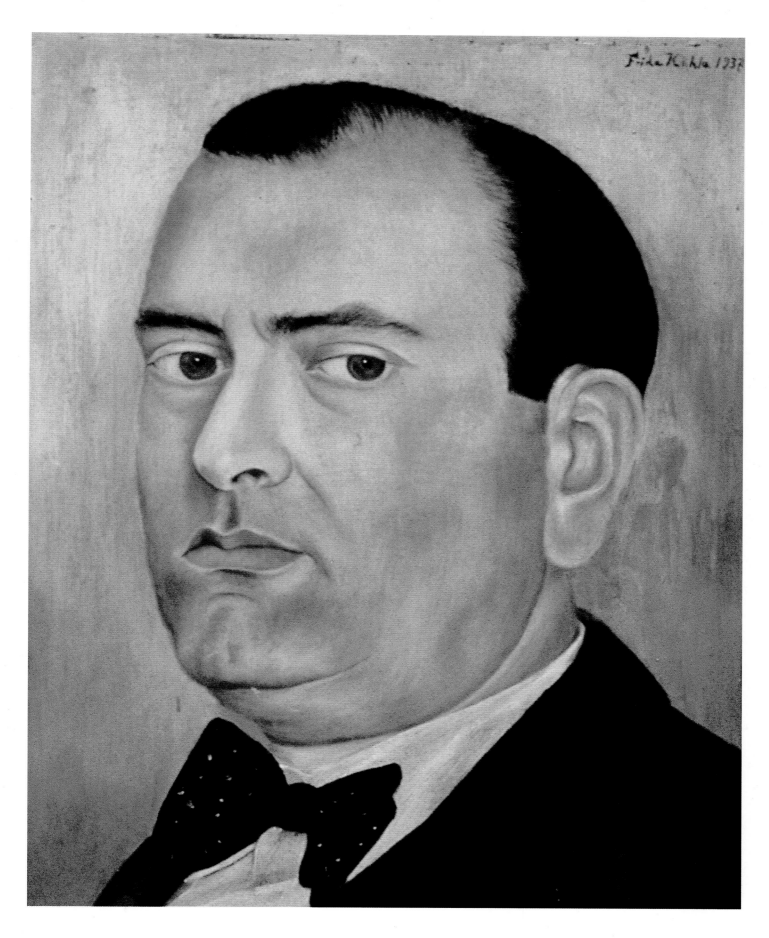

LEFT
Portrait of Diego Rivera, 1937
Oil on wood panel, 18 ⅛ × 12 ½ in.
Jacques and Natasha Gelman Collection, Mexico City

ABOVE
Portrait of Alberto Misrachi, 1937
Oil on metal, 13.5 × 10.6 in.
Private Collection

Self-Portrait Drawing, c. 1937
Pencil and colored pencil on tracing paper, 11.6 x 8.2 in.
Private Collection, USA

Me and My Doll, 1937
Oil on sheet metal, 15 ¾ x 12 ¼ in.
Jacques and Natasha Gelman Collection, Mexico City

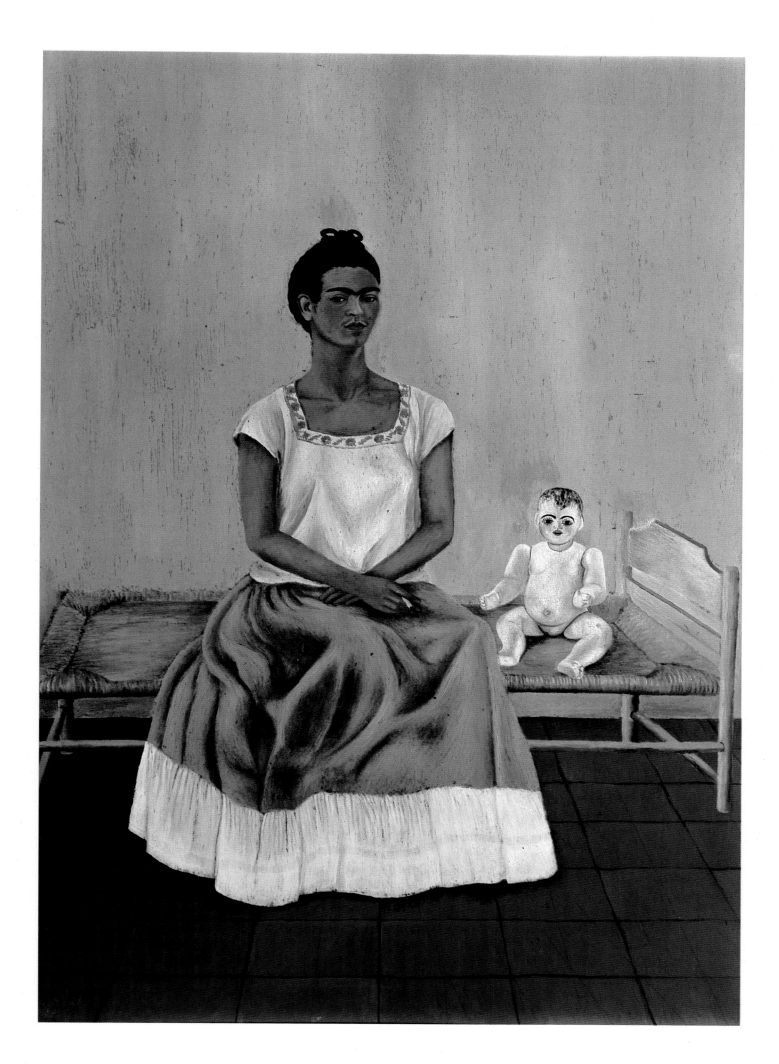

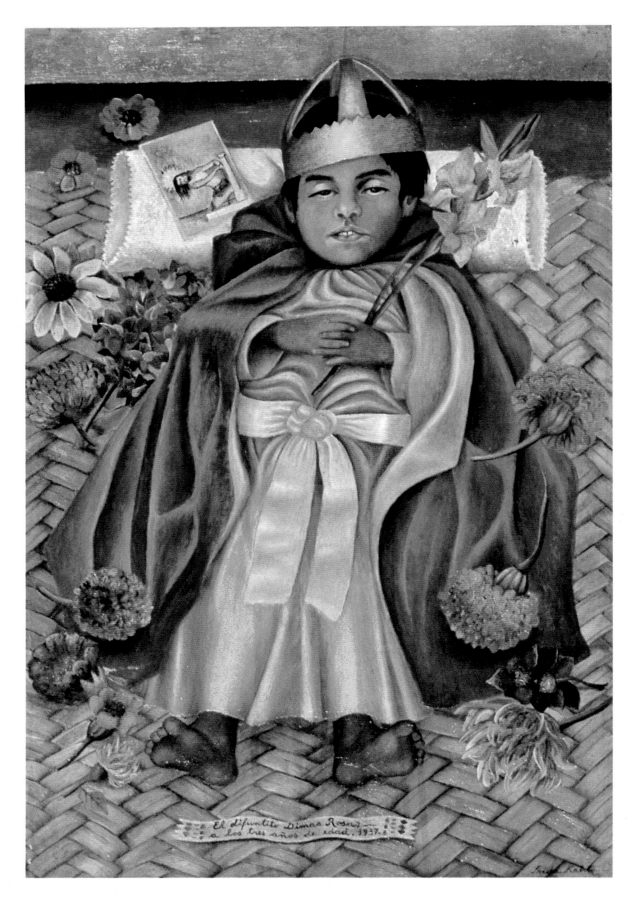

The Deceased Dimas, 1937
Oil on masonite, 18 7/8 x 12 3/8 in.
Dolores Olmedo Foundation, Mexico City

Memory, 1937
Oil on canvas, 15 3/4 x 11 in.
Private Collection

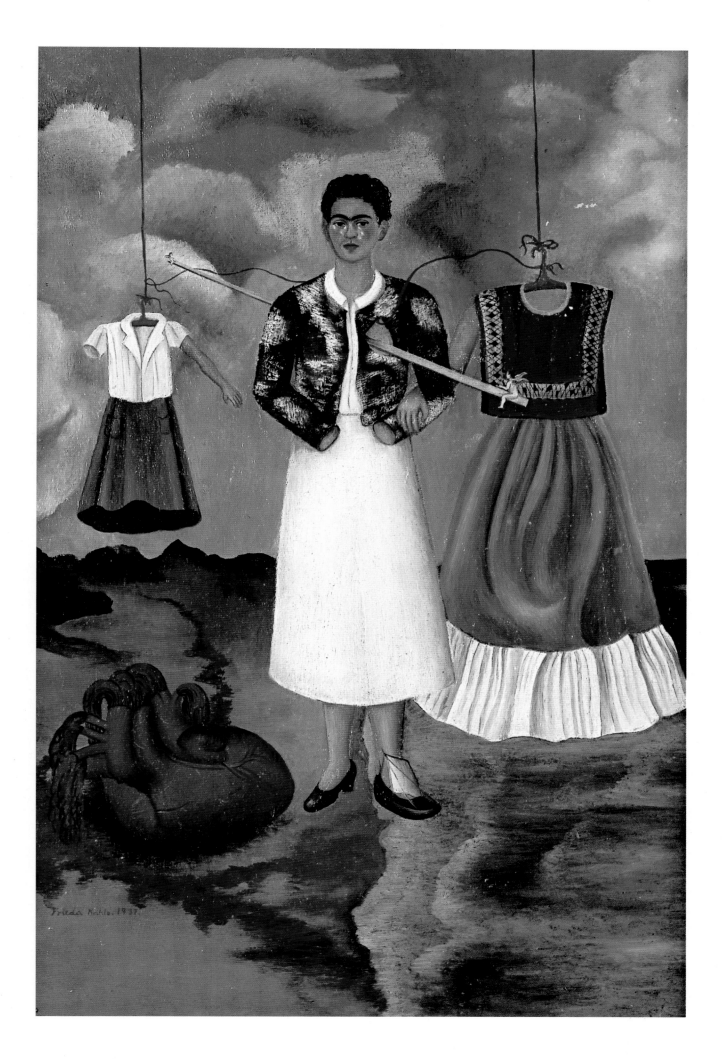

Four Inhabitants of Mexico, 1937
Oil on wood panel, 12 ¼ x 18 ¾ in.
Private Collection
Photo courtesy Sotheby's

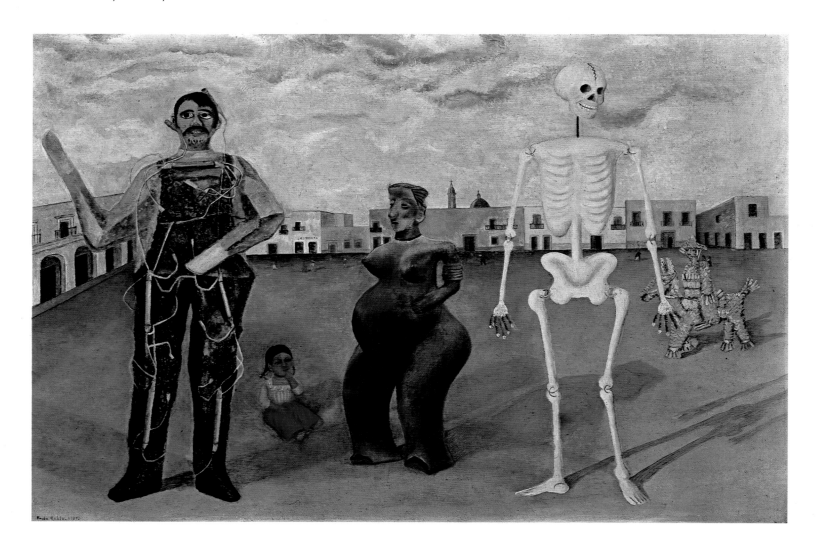

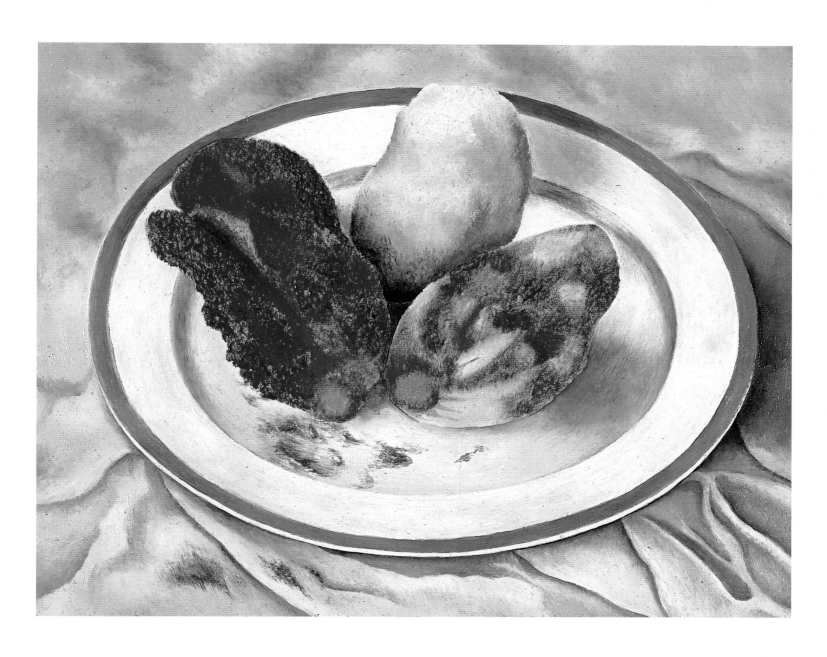

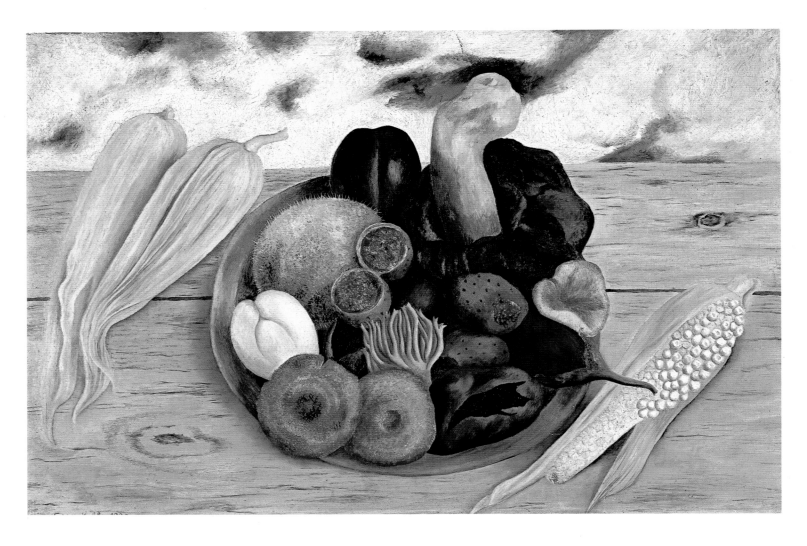

Fruit of the Earth, 1938
Oil on masonite, 15 ³/₄ x 23 ½ in.
Banco Nacional de Mexico

Still Life: "Life, How I Love You", 1938
Oil on panel, 22 x 14 in.
Private Collection, usa

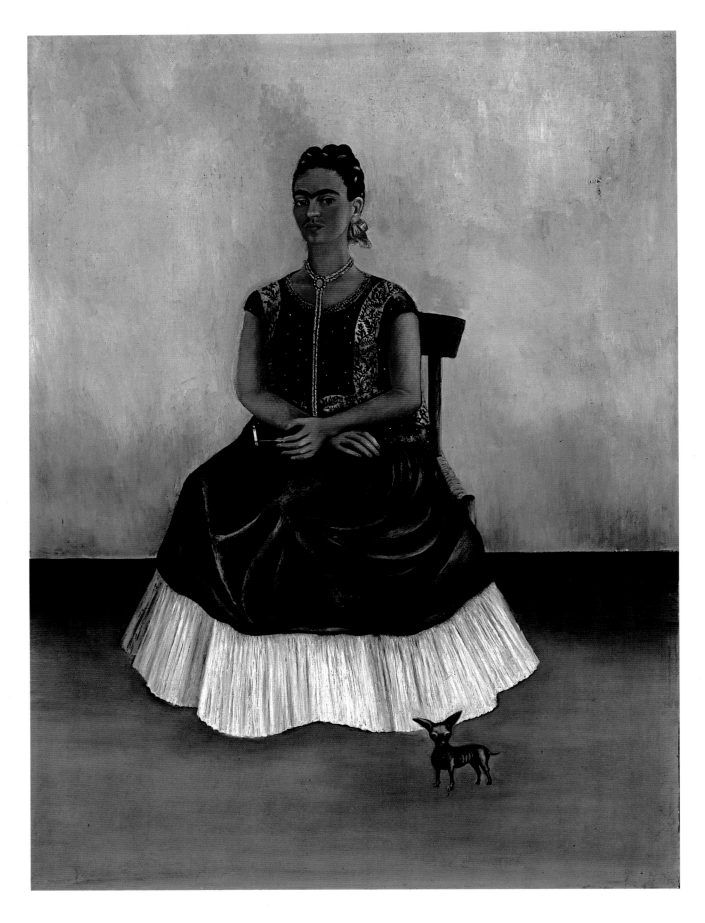

ABOVE
Itzcuintli Dog with Me, c. 1938
Oil on canvas, 28 1/8 x 20 5/8 in.
Private Collection, USA

RIGHT
Self-Portrait with Monkey, 1938
Oil on masonite, 16 x 12 in.
Bequest of A. Conger Goodyear, 1966
Albright-Knox Art Gallery, Buffalo, NY (66:9:10)

74

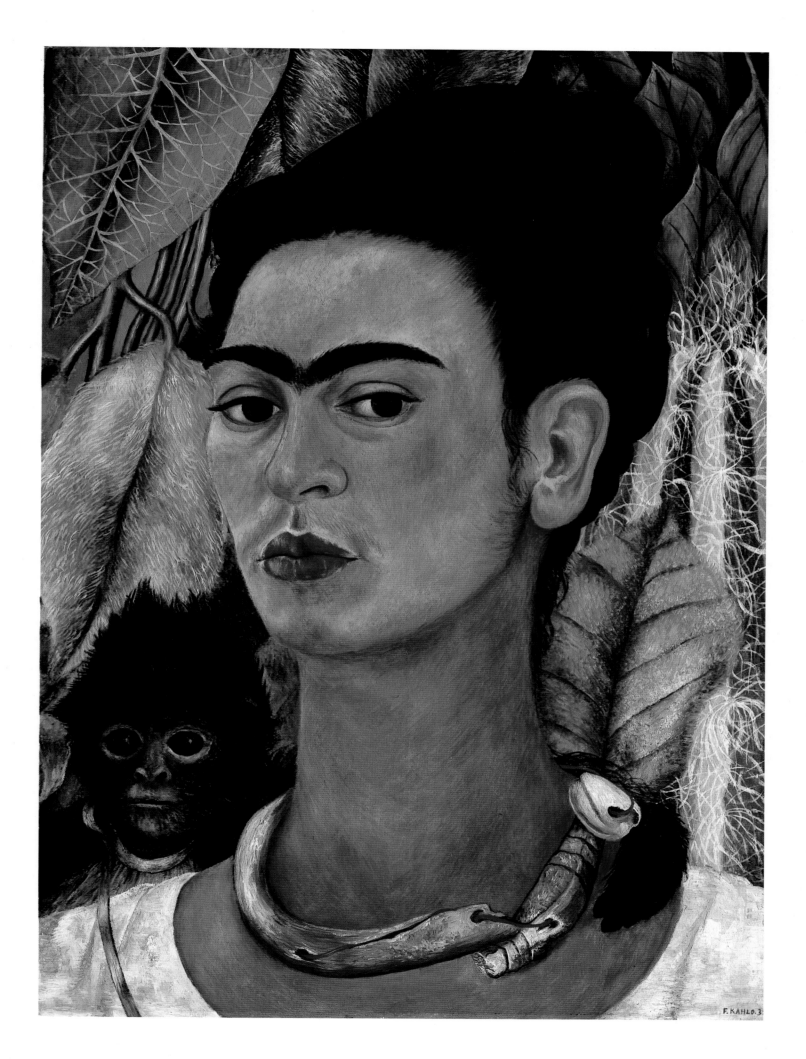

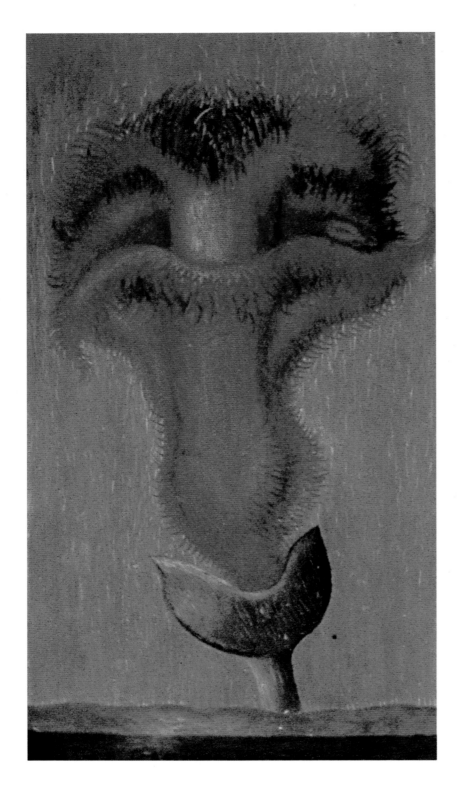

ABOVE
Xóchitl, Flower of Life, 1938
Oil on sheet metal, 7 x 3 3/4 in.
Collection of Dr. Rodolfo Gómez, Mexico City

RIGHT
Self-Portrait: The Frame, 1938
Oil on aluminum and glass, 18 7/8 x 12 3/8 in.
Musée National d'Art Moderne, Paris

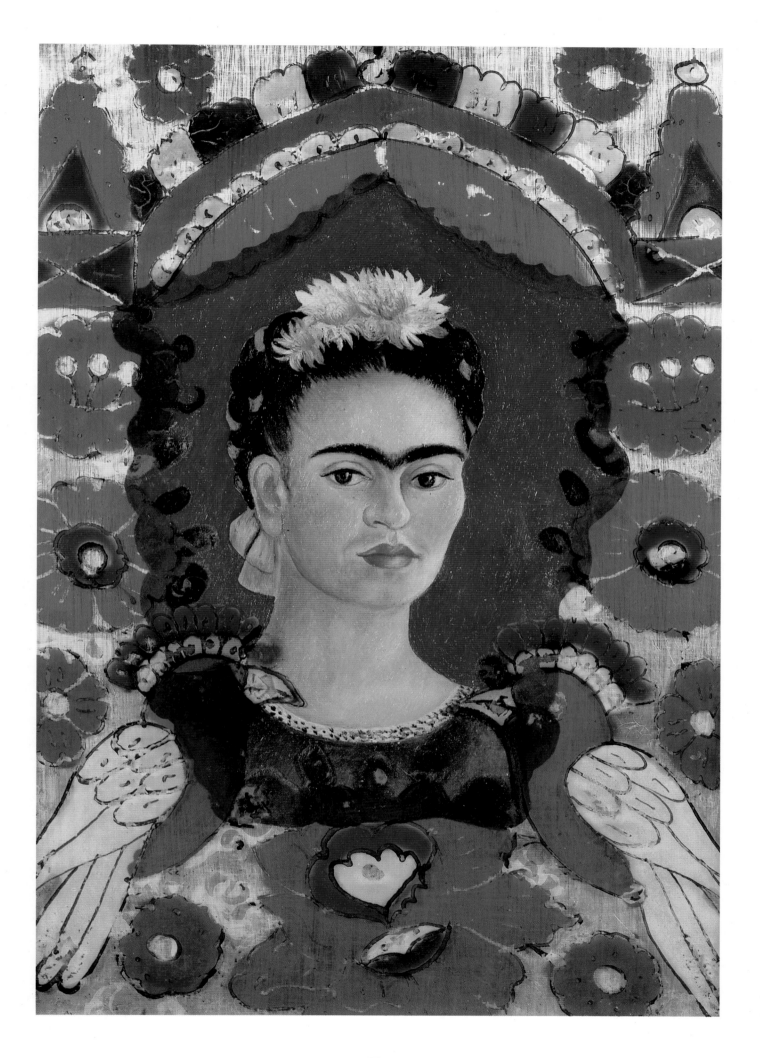

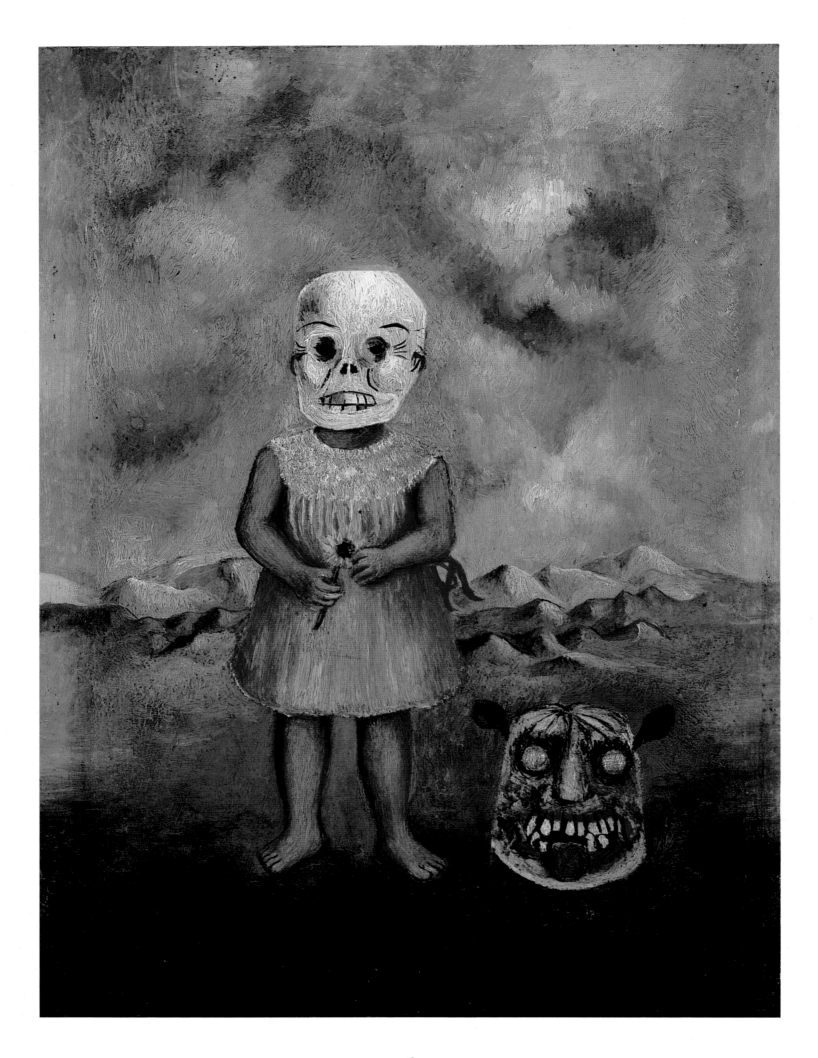

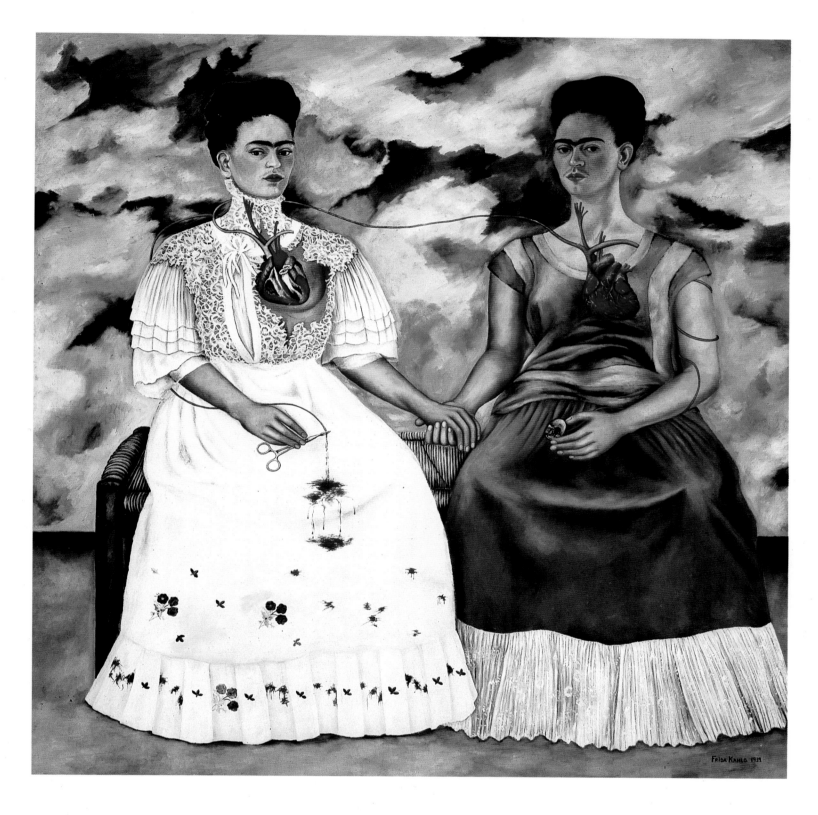

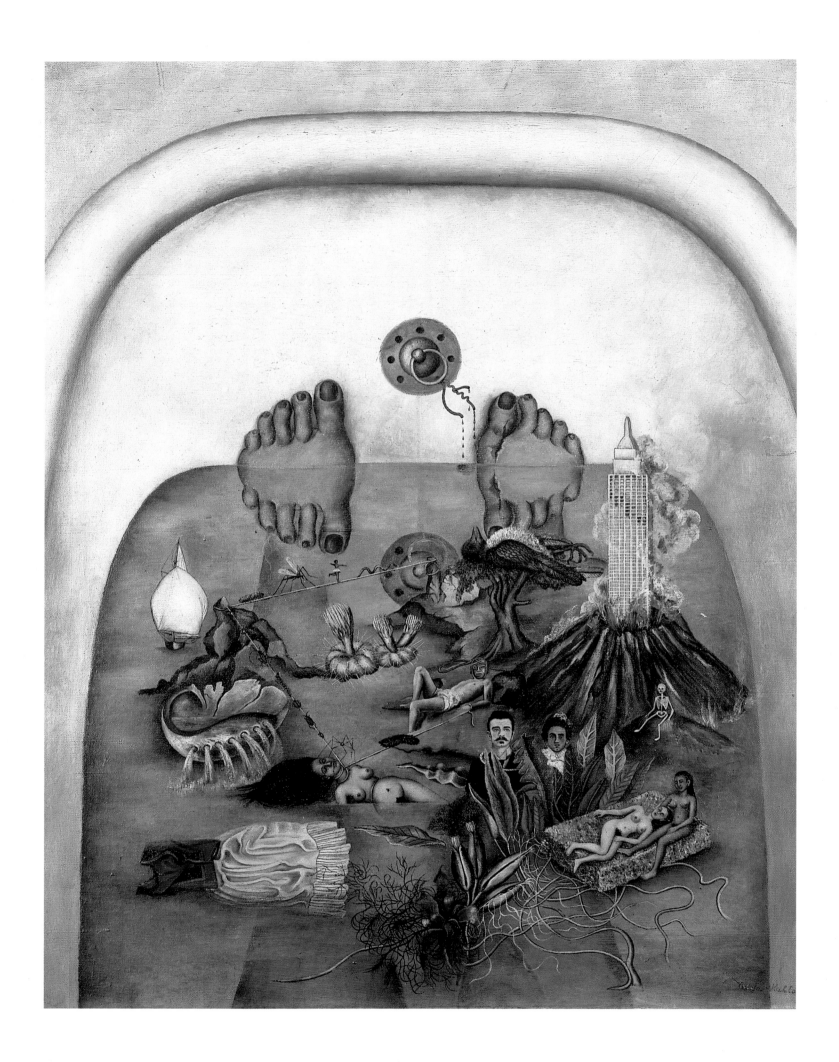

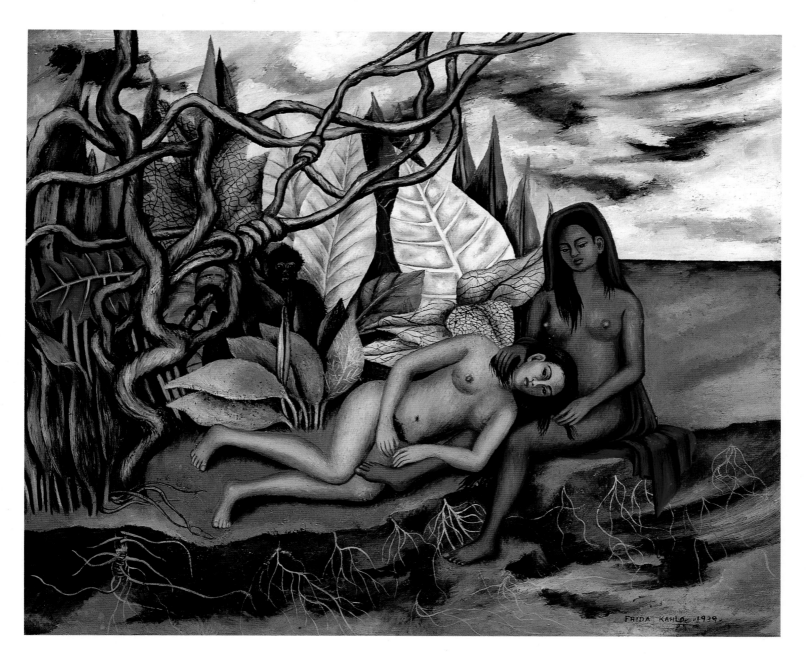

Earth Herself or Two Nudes in a Jungle, 1939
Oil on sheet metal, 9 7/8 x 11 7/8 in.
Mary-Anne Martin/Fine Art, NY

What the Water Gave Me, 1938
Oil on canvas, 38 x 30 in.
Collection of Isidore Ducasse Fine Arts, New York, NY

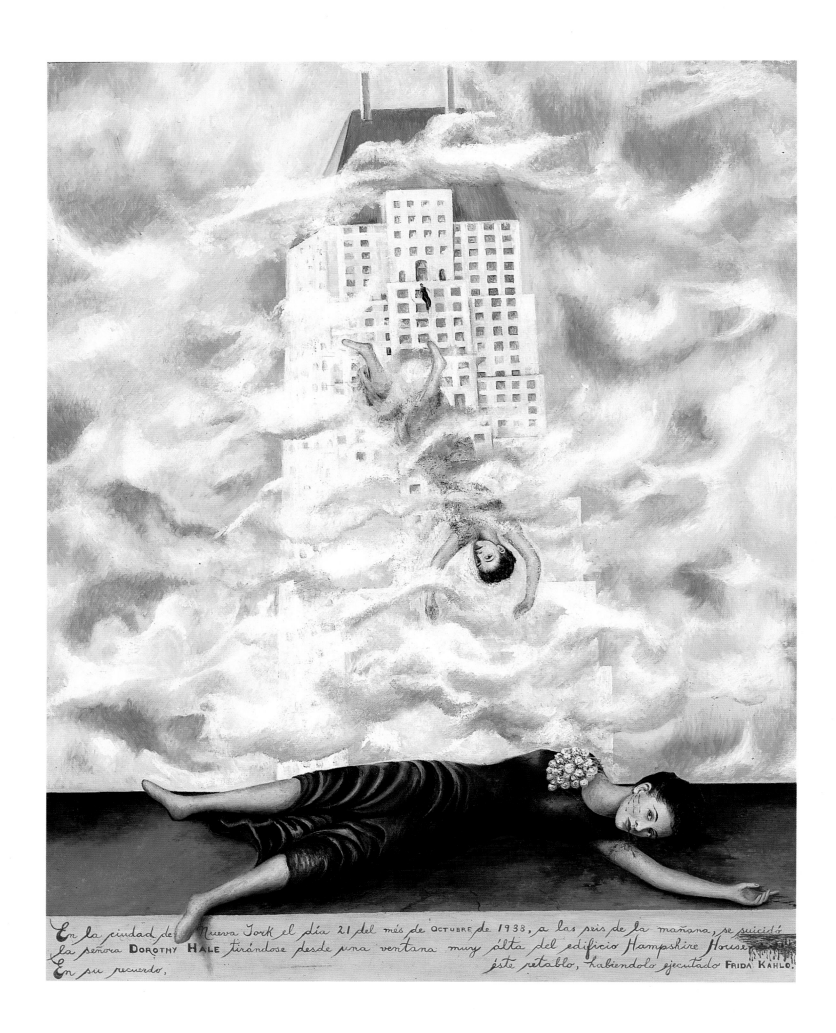

En la ciudad de Nueva York el día 21 del més de OCTUBRE de 1938, a las seis de la mañana, se suicidó la señora DOROTHY HALE tirándose desde una ventana muy alta del edificio Hampshire House. En su recuerdo, éste retablo, habiendolo ejecutado FRIDA KAHLO.

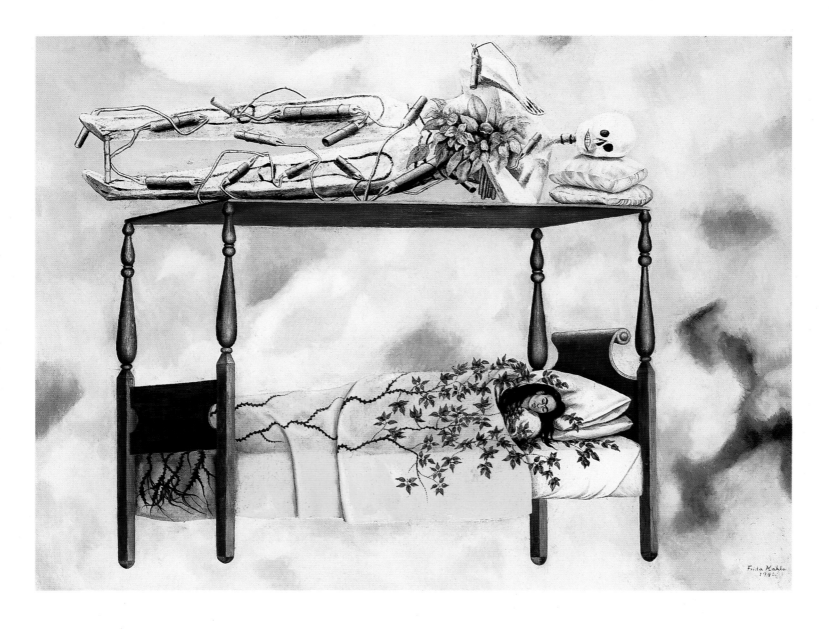

83

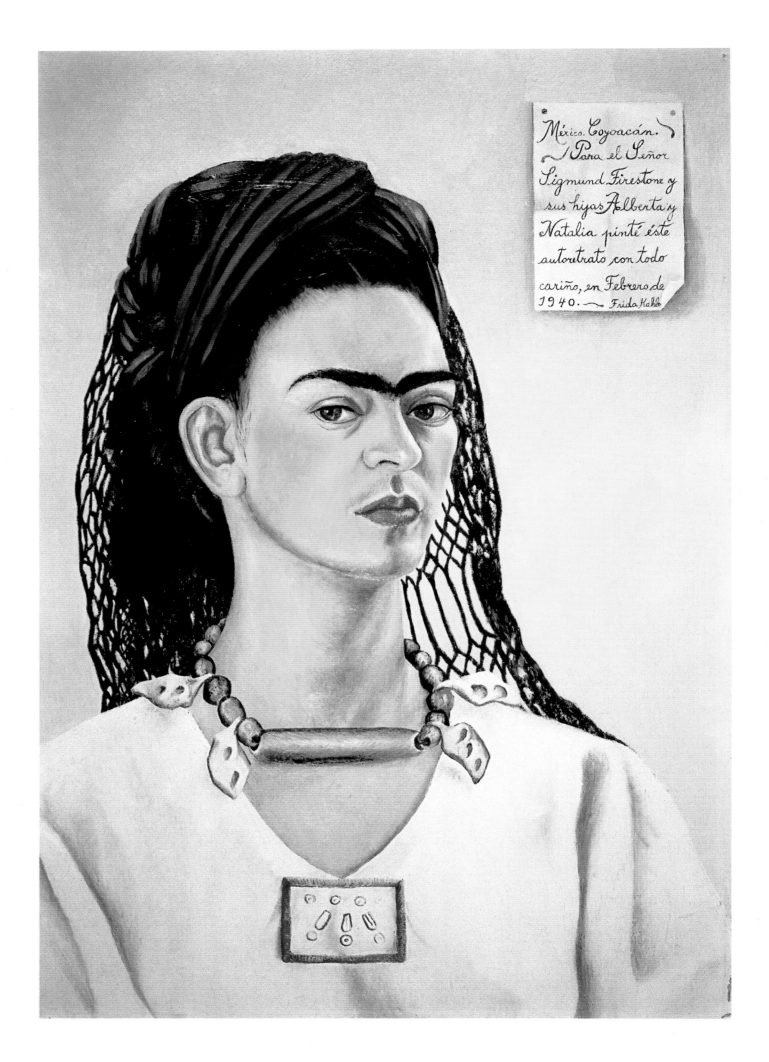

México. Coyoacán.
Para el Señor
Sigmund Firestone y
sus hijas Alberta y
Natalia pinté éste
autoretrato con todo
cariño, en Febrero de
1940. — Frida Kahlo

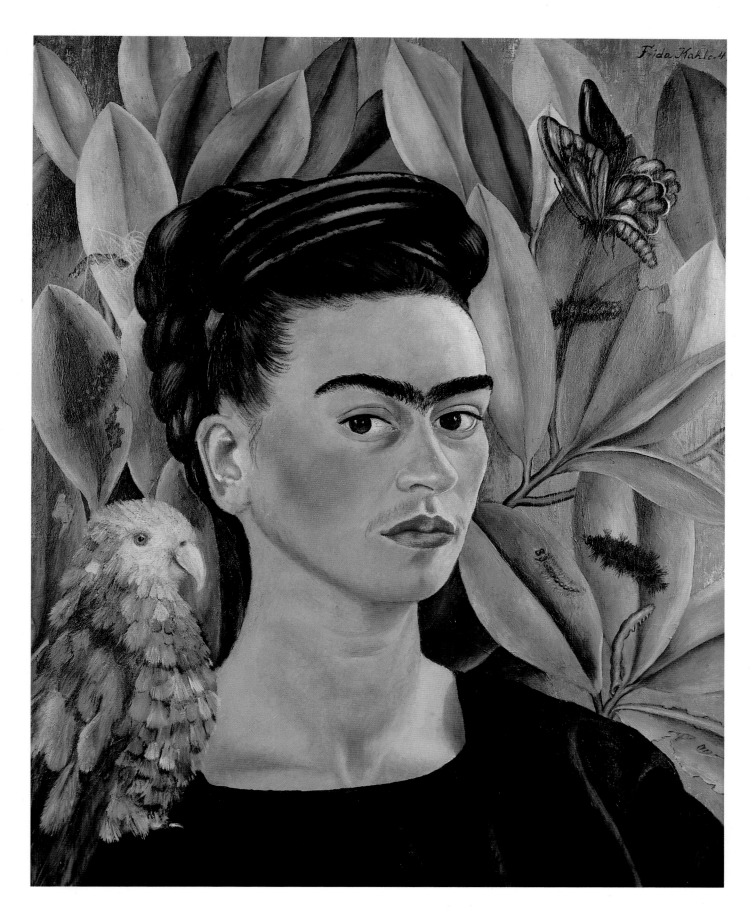

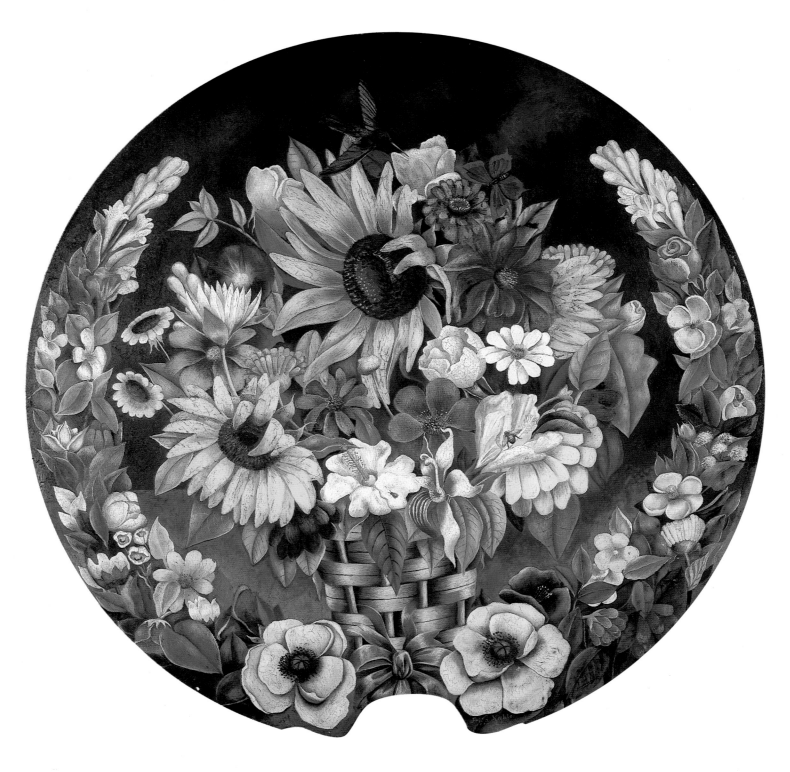

ABOVE
The Flower Basket, 1941
Oil on copper, 25.3 in. diameter
Private Collection, USA

RIGHT
Self-Portrait with Braid, 1941
Oil on masonite, 20 x 15 ¼ in.
Jacques and Natasha Gelman Collection, Mexico City

86

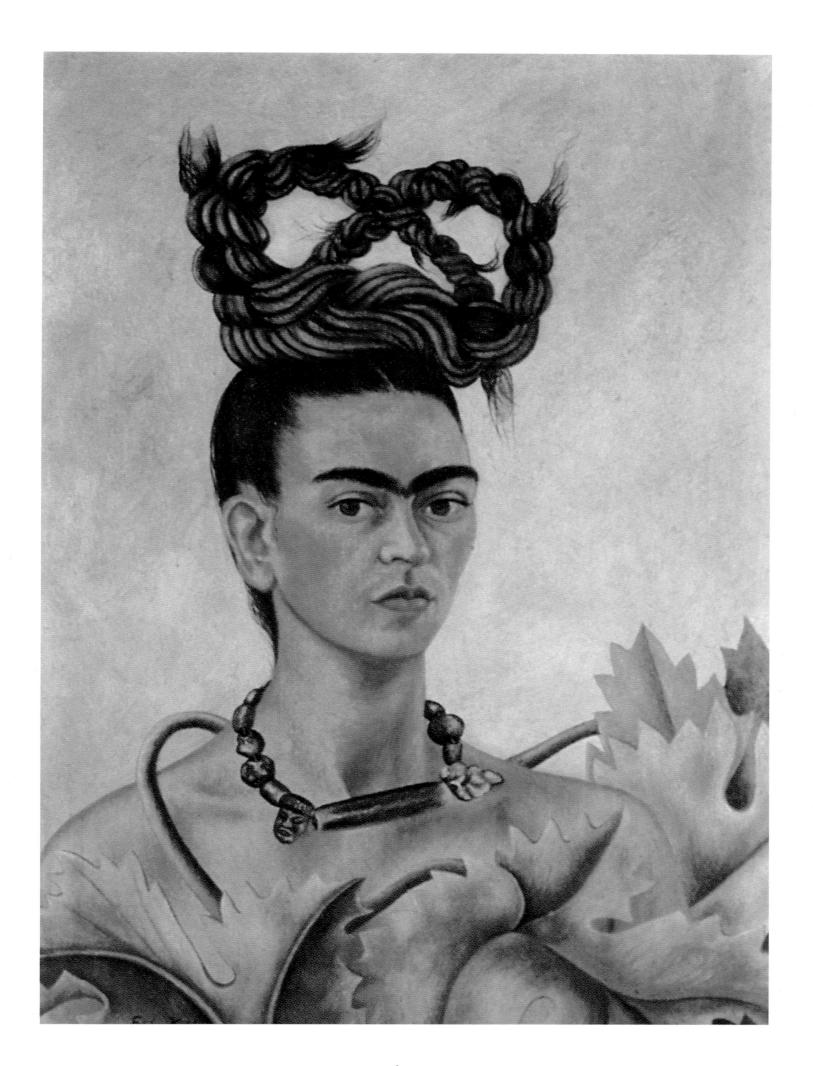

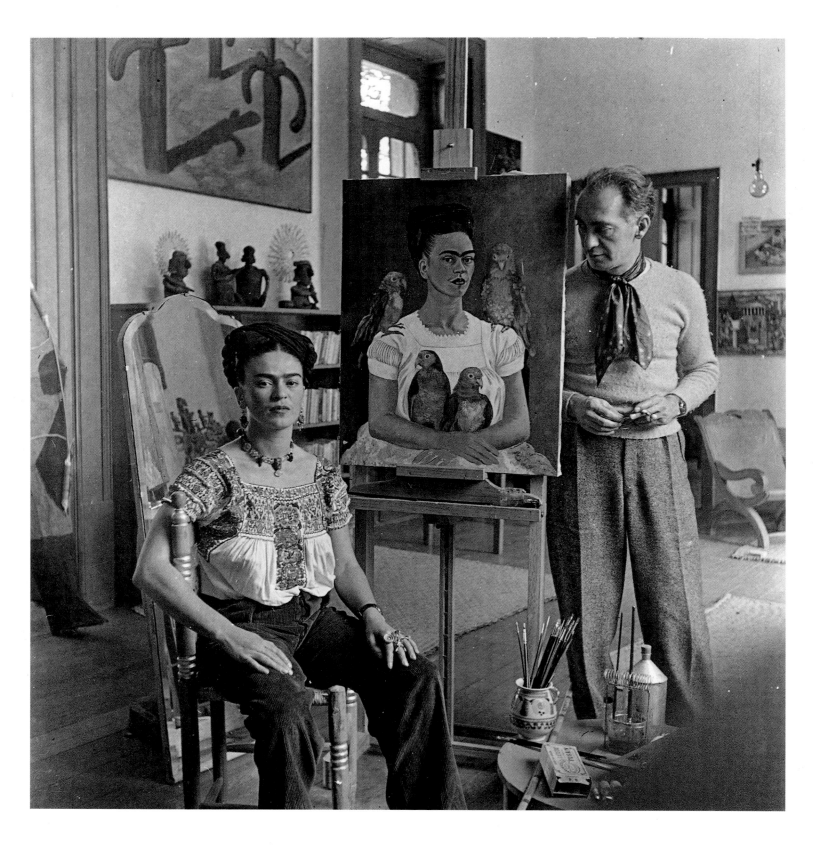

ABOVE
Nickolas Muray
Self-Portrait with Frida in her Studio, August 1941
Photo courtesy Mimi Muray

RIGHT
Me and My Parrots, 1941
Oil on canvas, 32 x 24 ½ in.
Private Collection, USA

88

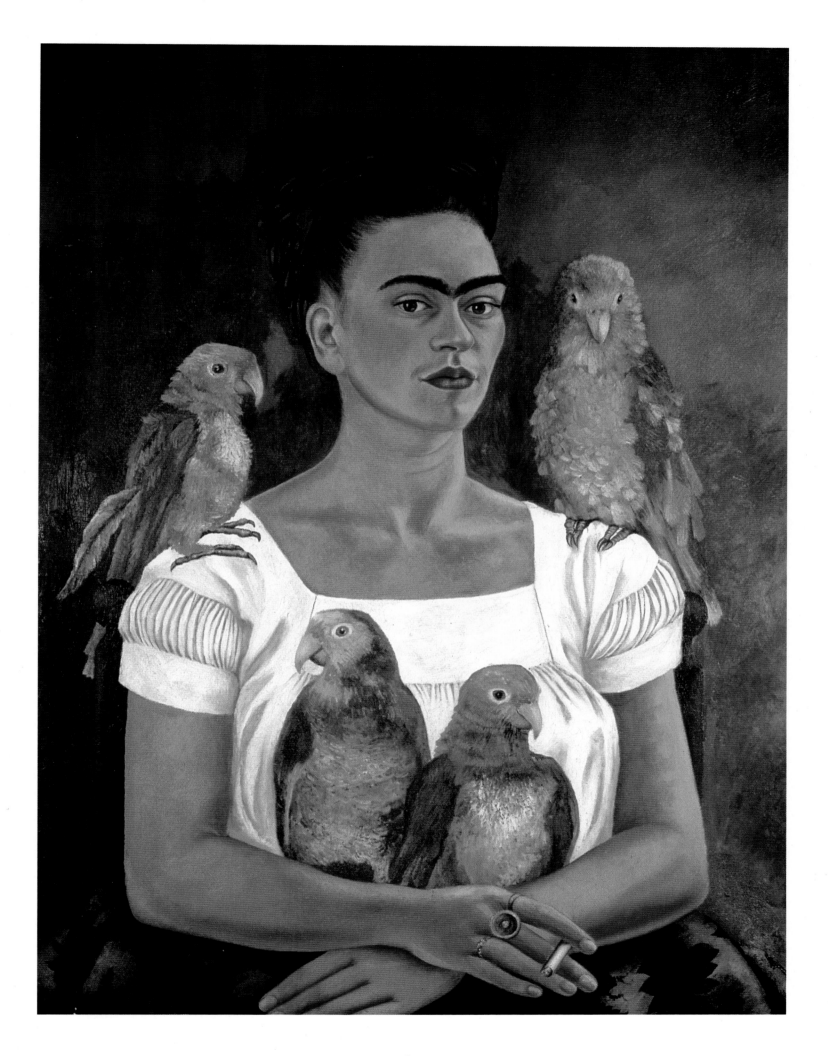

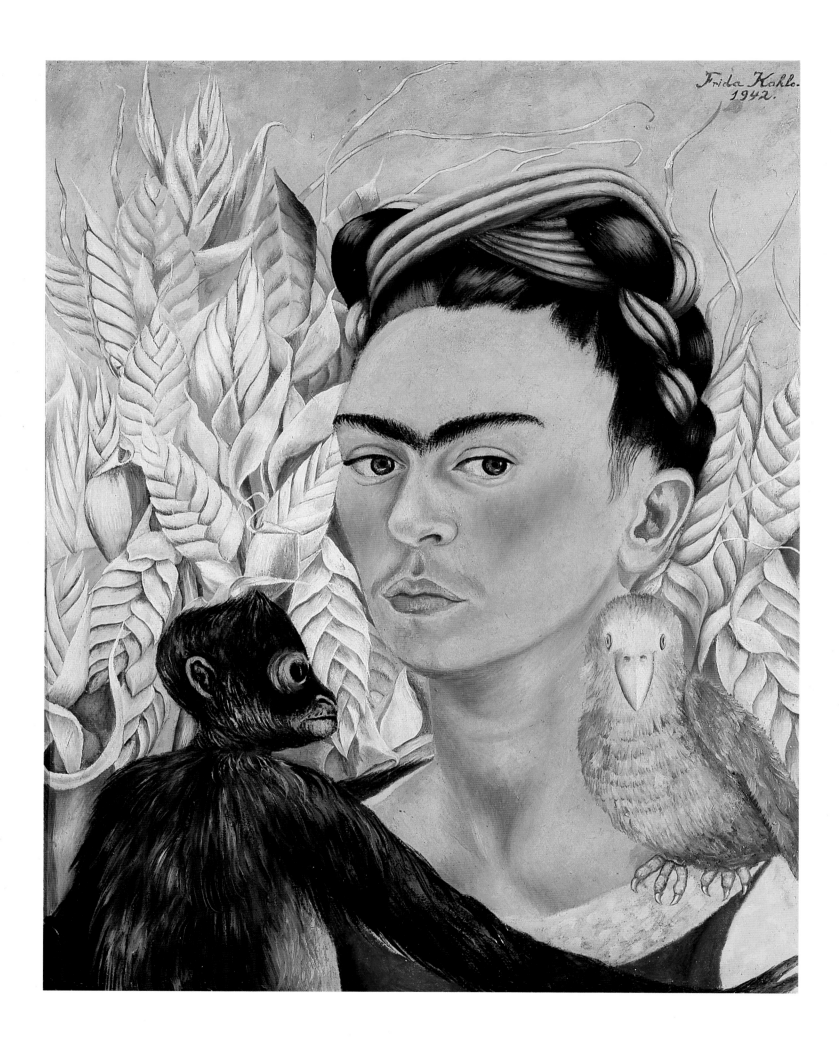

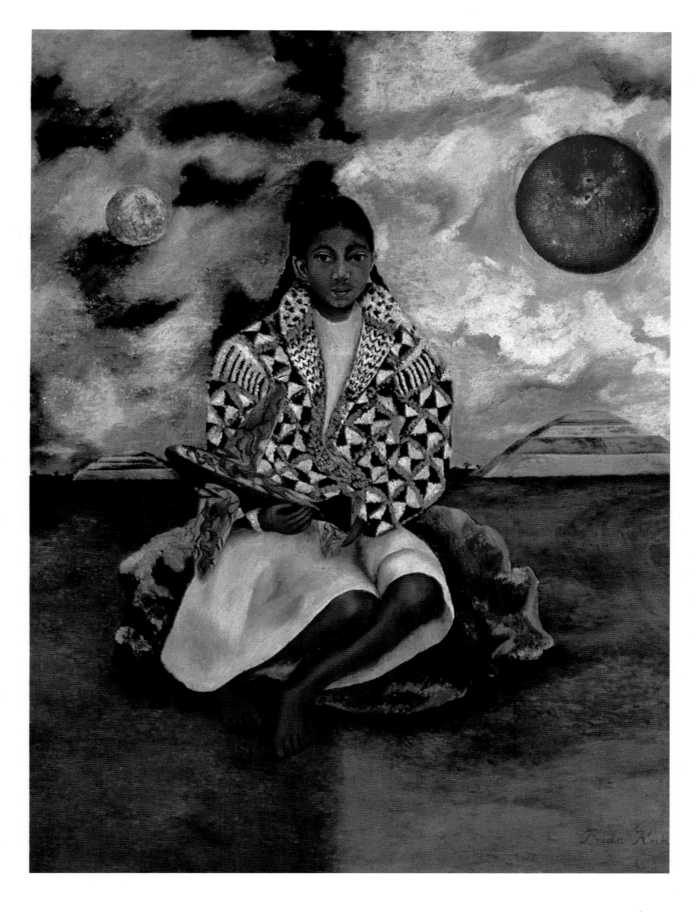

ABOVE
Portrait of Lucha Maria, a girl from Tehuacan, 1942
Oil on masonite, 21.4 x 16.9 in.
Private Collection

LEFT
Self-Portrait with Monkey and Parrot, 1942
Oil on masonite, 21 x 17 in.
Constantini Collection, Argentina

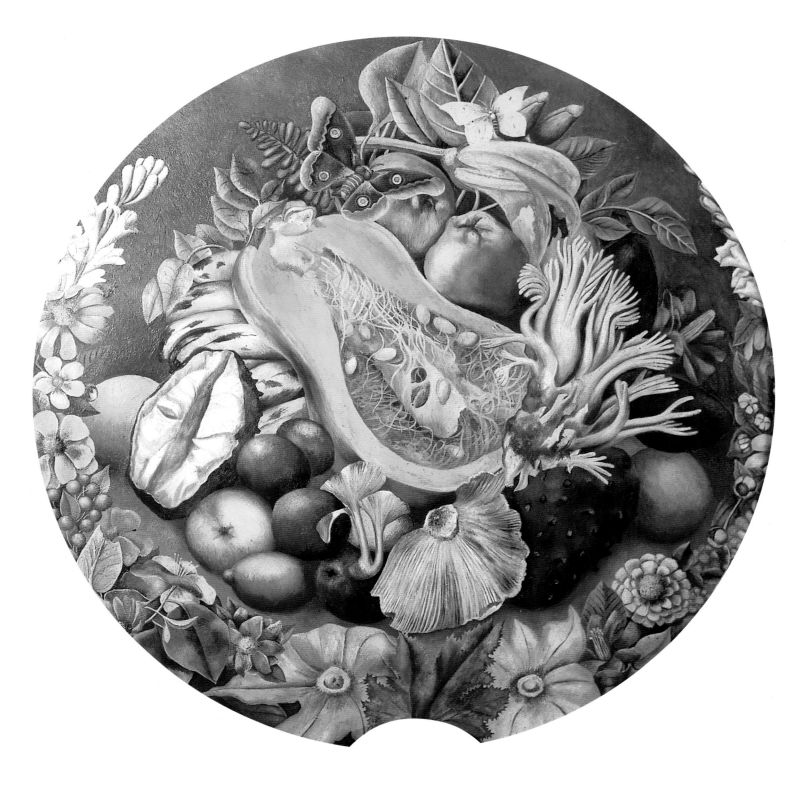

Still Life, 1942
Oil on copper, 24.8 in. diameter
Frida Kahlo Museum, Mexico City

The Bride That Becomes Frightened When She Sees Life Open, 1943
Oil on canvas, 24.8 x 32 in.
Jacques and Natasha Gelman Collection, Mexico City

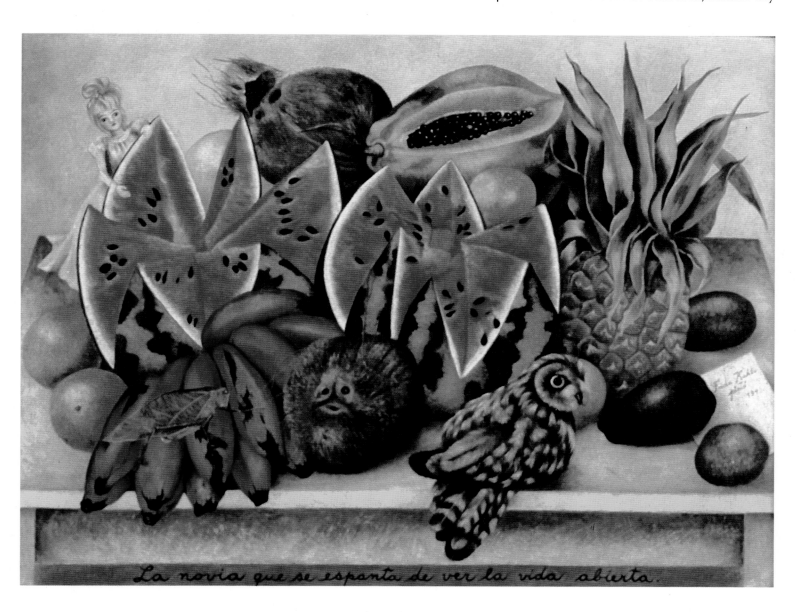

La novia que se espanta de ver la vida abierta.

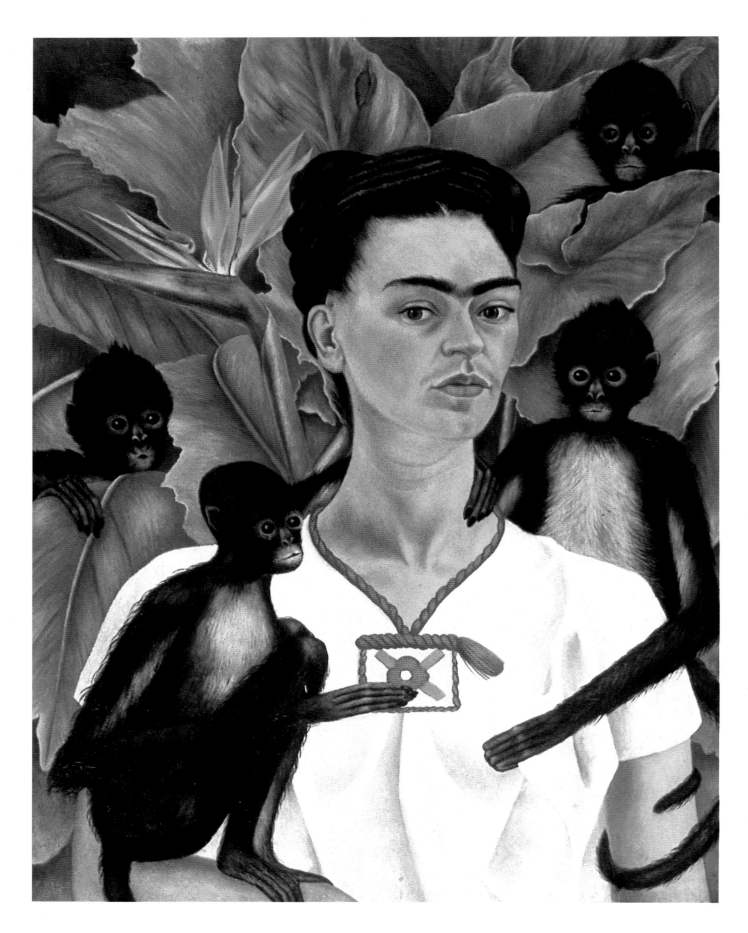

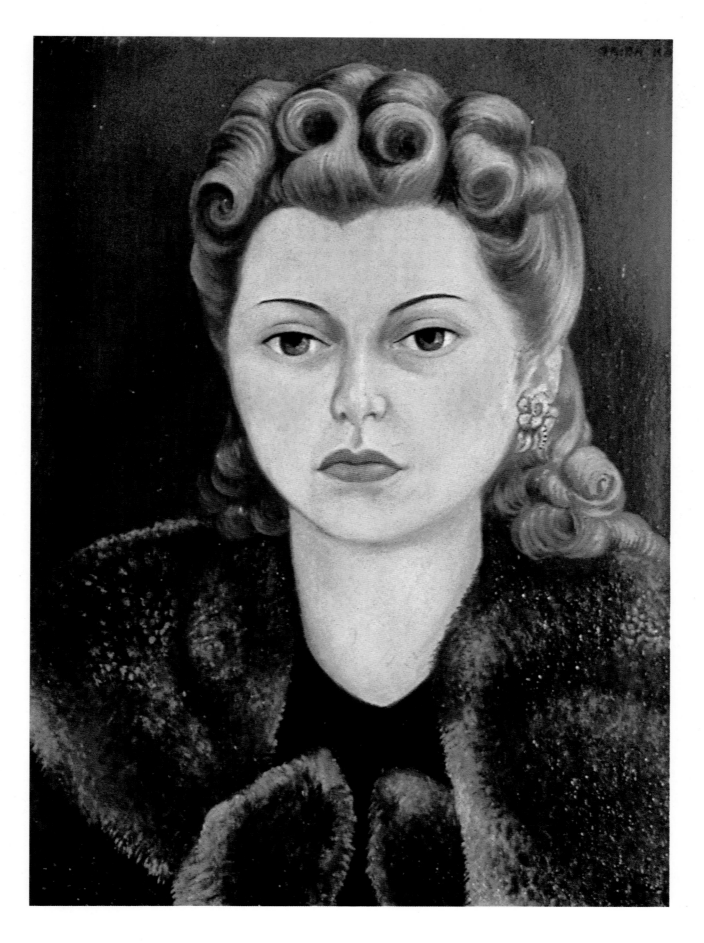

ABOVE
Portrait of Natasha Gelman, 1943
Oil on canvas, 11.4 x 9 in.
Jacques and Natasha Gelman Collection, Mexico City

95

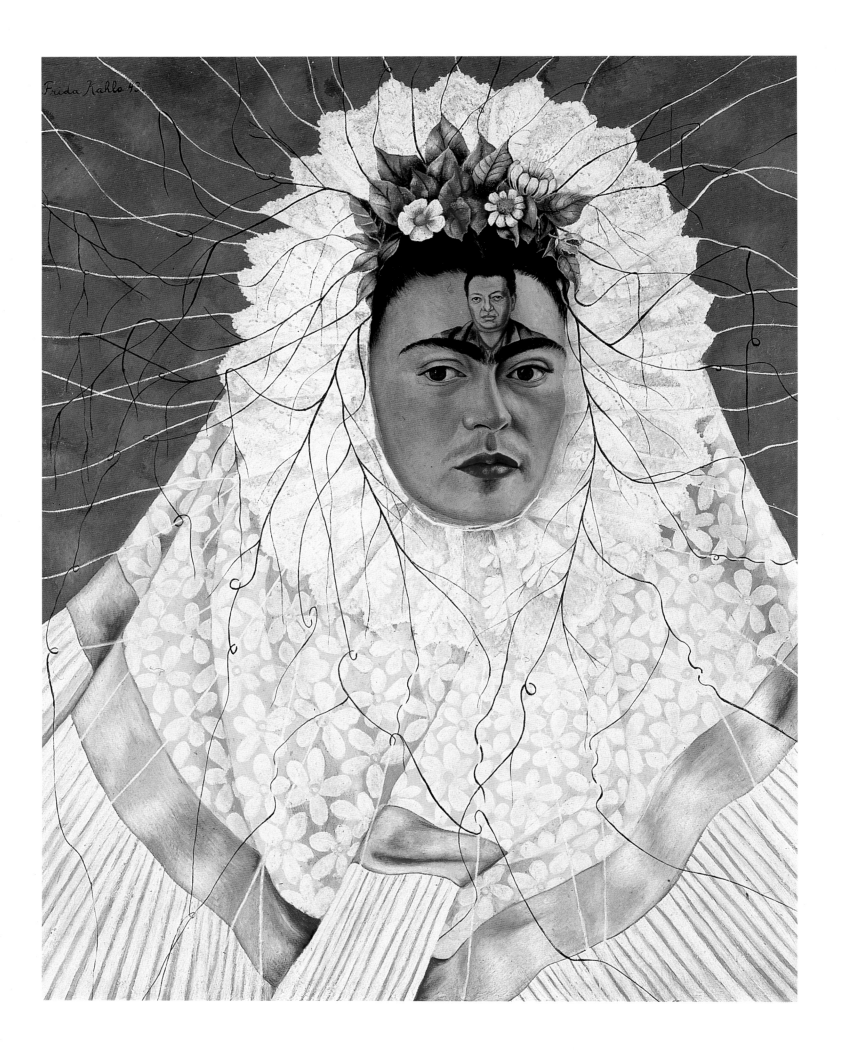

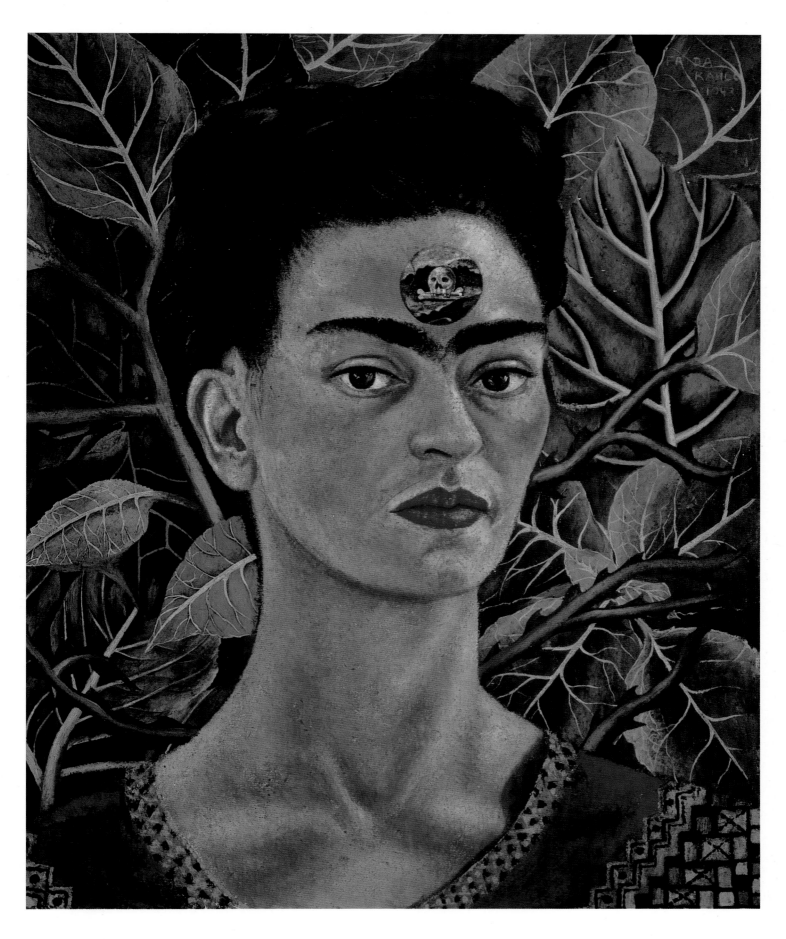

Diego in My Thoughts, 1943
Oil on masonite, 29 7/8 x 24 in.
Jacques and Natasha Gelman Collection, Mexico City

ABOVE
Thinking About Death, 1943
Oil on canvas mounted on masonite, 17 3/4 x 14 1/2 in.
Private Collection

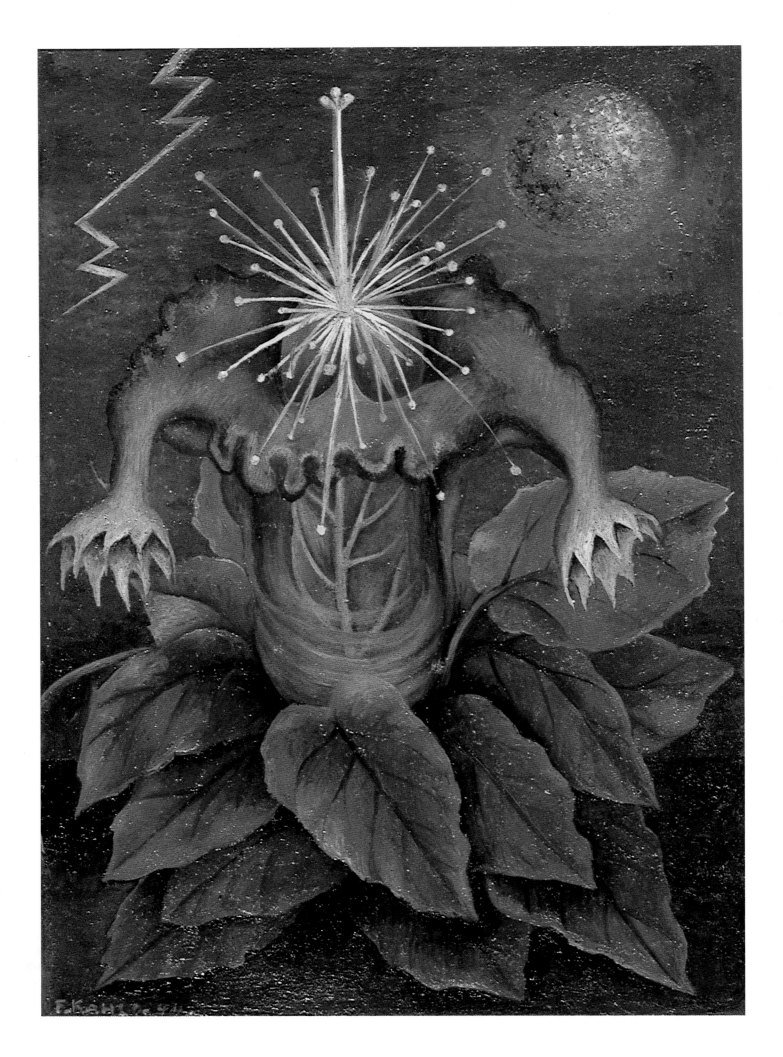

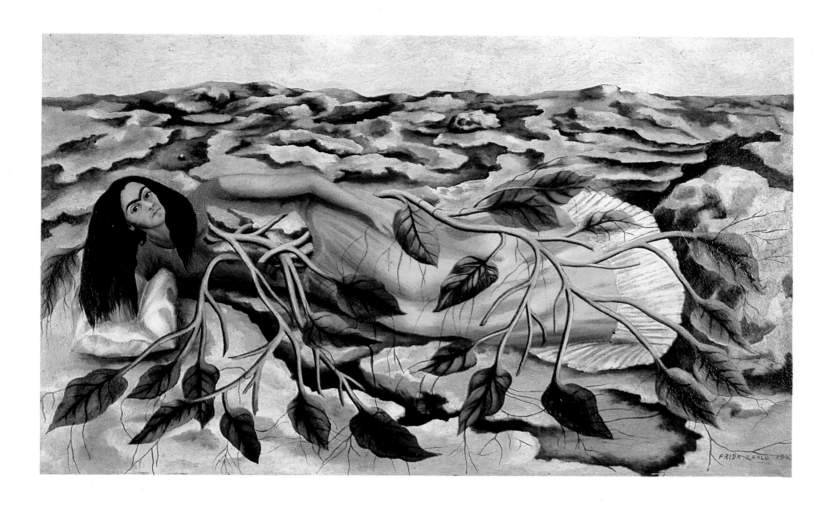

ABOVE
Roots, 1943
Oil on metal, 11 ³/₄ x 14 ¹/₂ in.
Private Collection, Houston

LEFT
Flower of Life, 1943
Oil on Masonite, 11 ¹/₂ x 9 in.
Dolores Olmedo Foundation, Mexico City

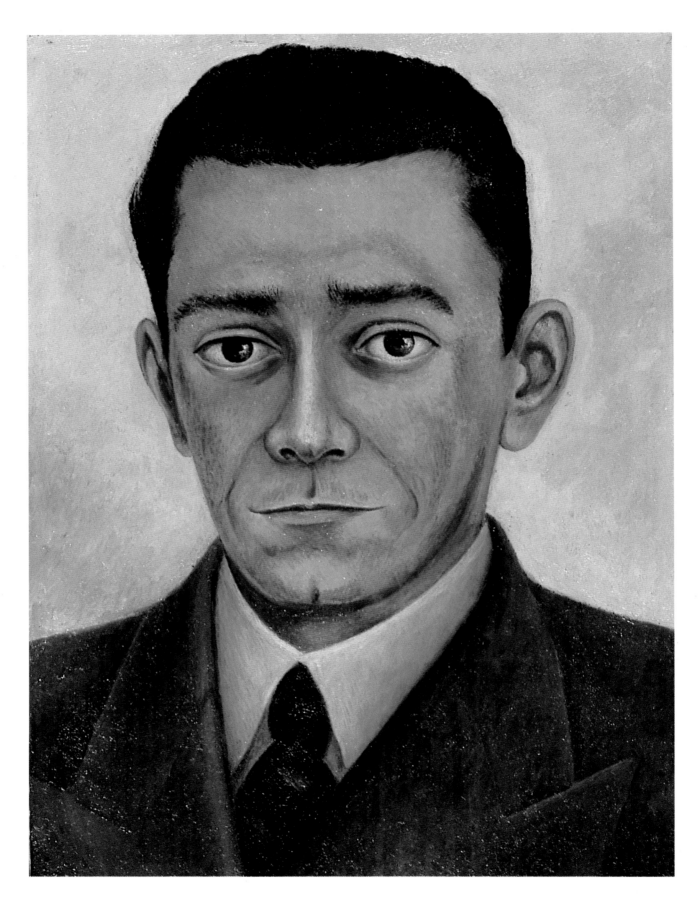

Portrait of the Engineer Eduardo Morillo Safa, 1944
Oil on masonite, 15 ½ x 11 ½ in.
Dolores Olmedo Foundation, Mexico City

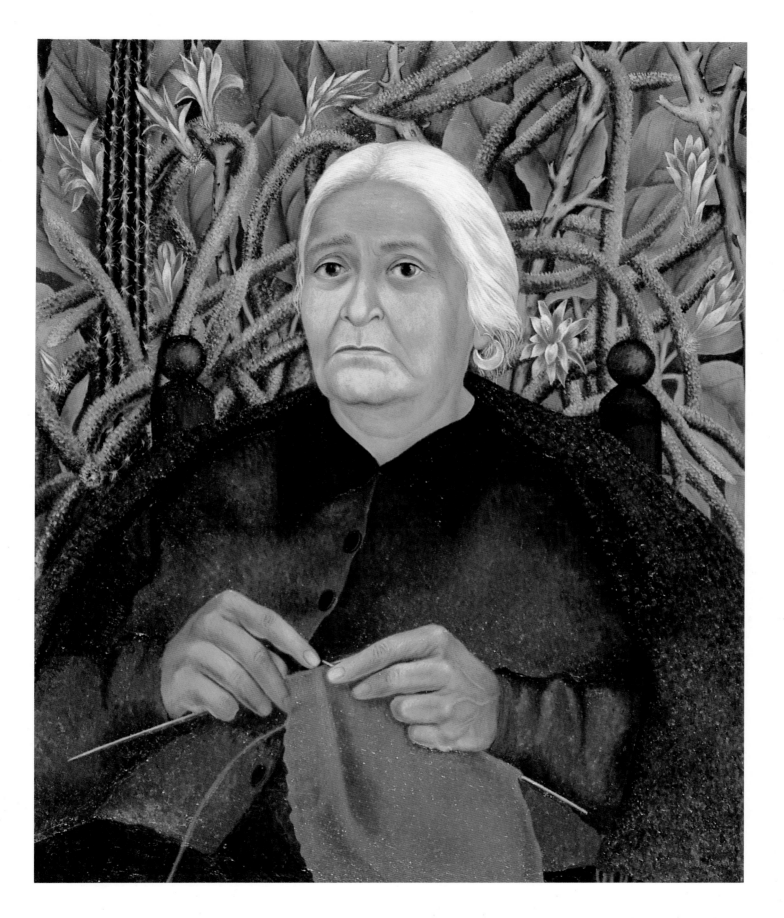

ABOVE
Doña Rosita Morillo, 1944
Oil on masonite, 30 ½ x 28 ½ in.
Dolores Olmedo Foundation, Mexico City

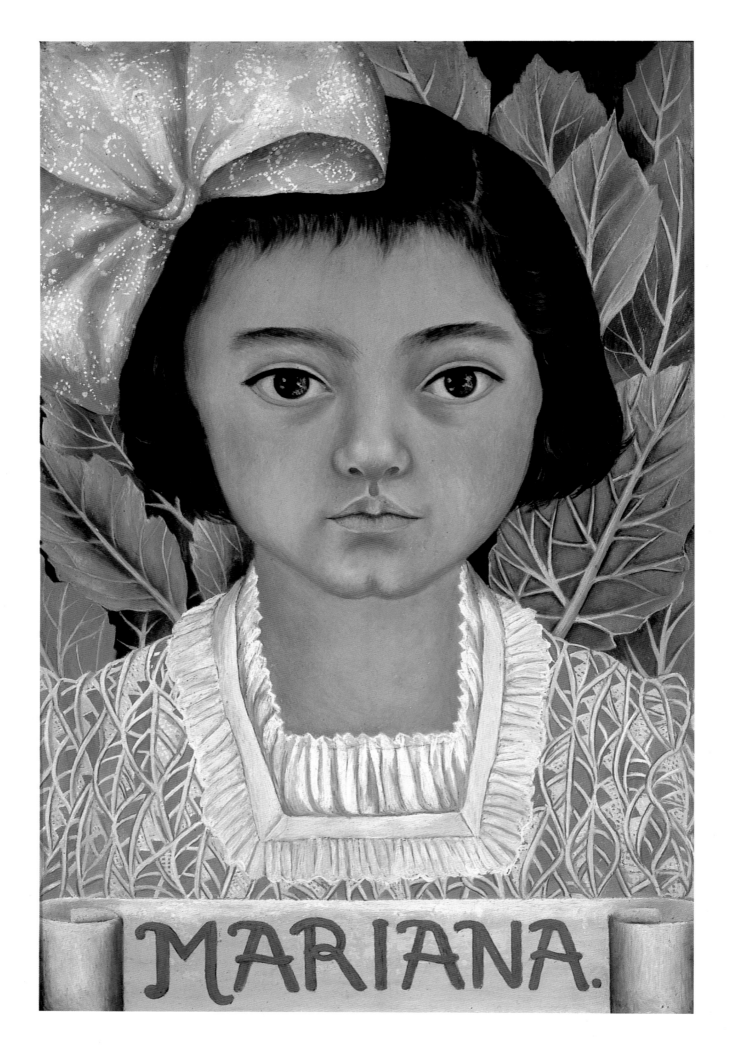

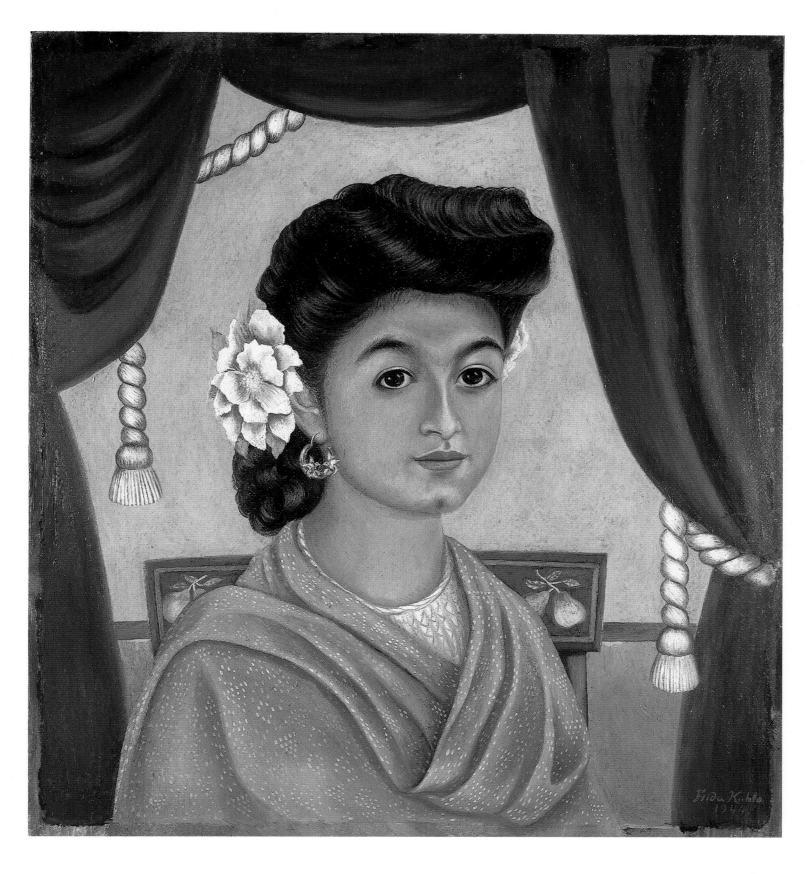

ABOVE
Portrait of Lupita Morillo, 1944
Oil on masonite, 22 x 19 ¾ in.
Private Collection

ABOVE
Portrait of Lupita Morillo, 1944
Oil on masonite, 22 x 19 ¾ in.
Private Collection

LEFT
Portrait of Mariana Morillo, 1944
Oil on canvas, 15 ½ x 11 ¼ in.
Private Collection

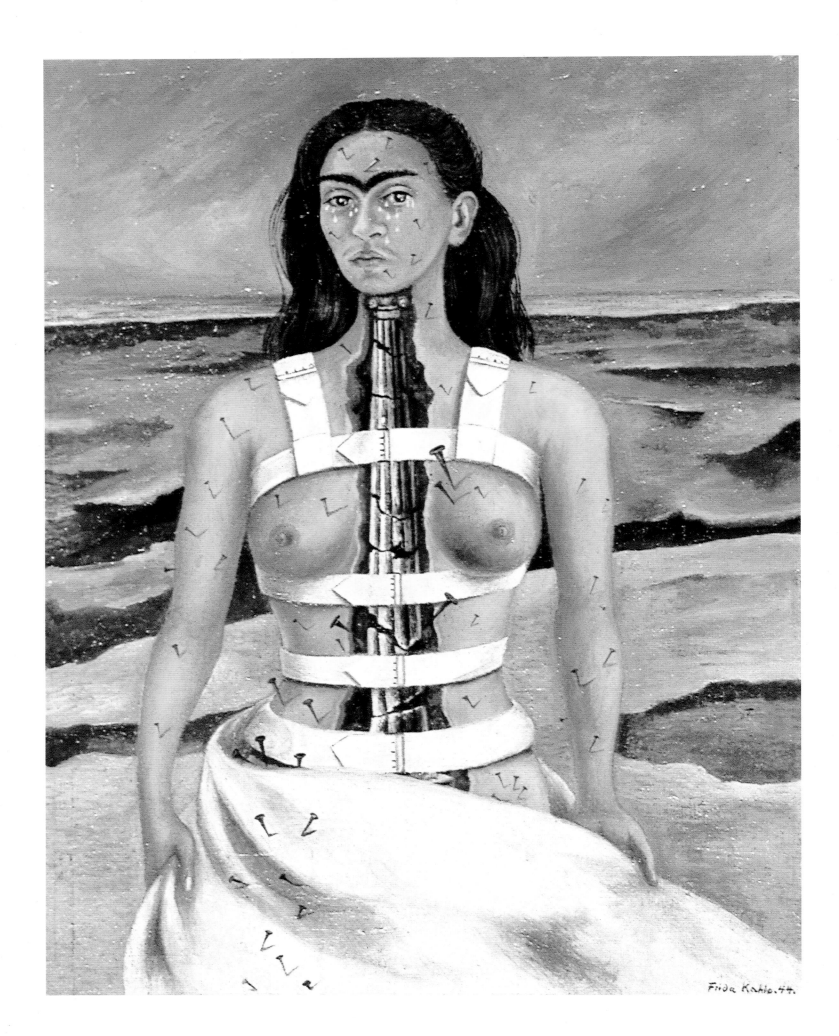

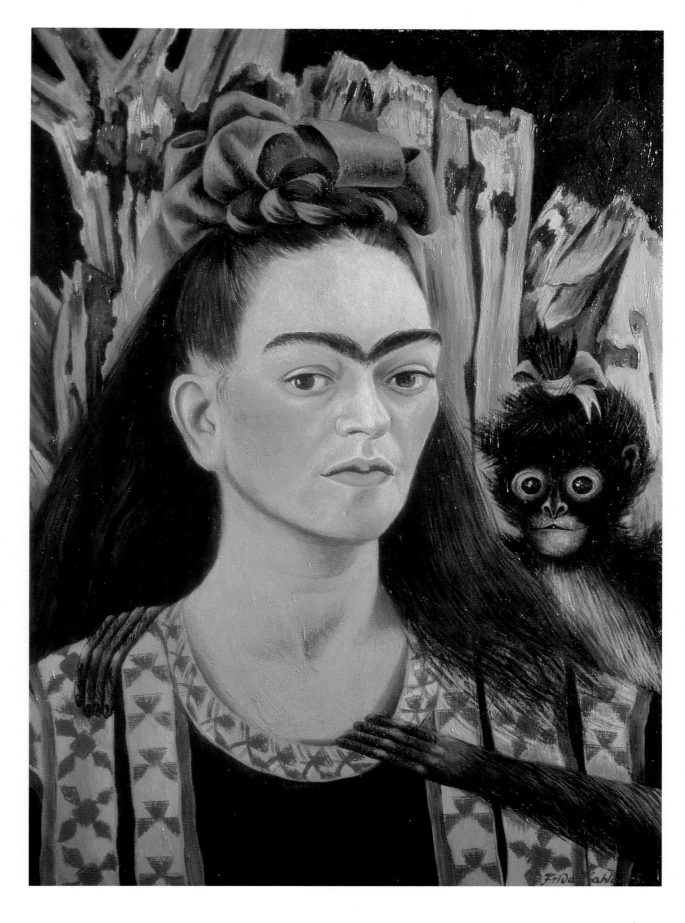

LEFT
The Broken Column, 1944
Oil on masonite, 15 ³/4 x 12 ¹/4 in.
Dolores Olmedo Foundation, Mexico City

ABOVE
Self-Portrait with Monkey, 1945
Oil on masonite, 23.6 x 16.7 in.
Fondación Robert Brady, A.C.

105

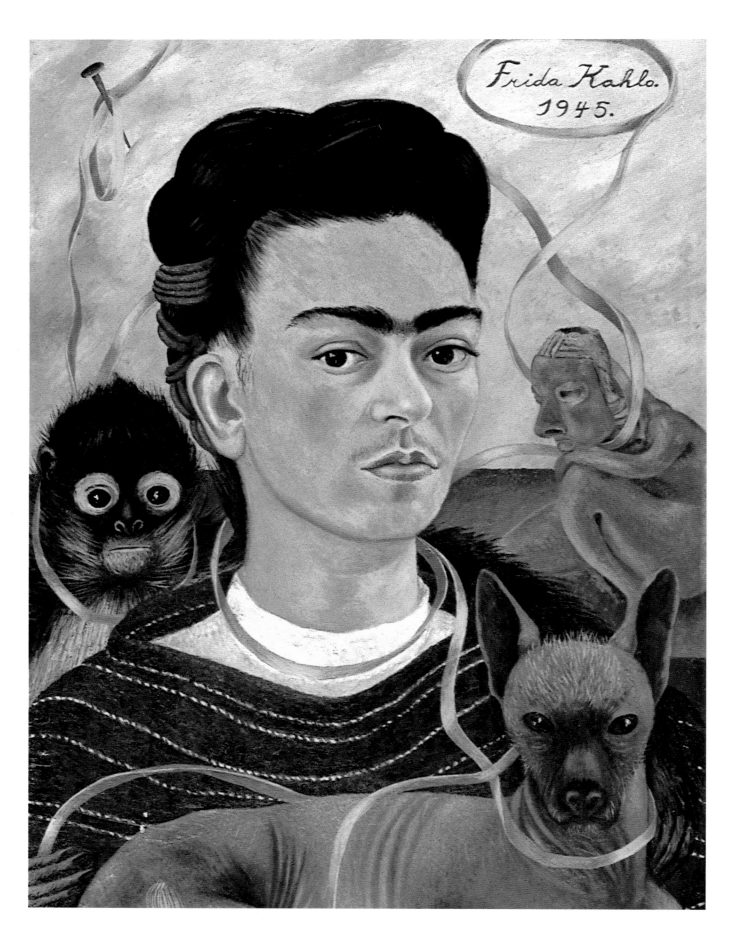

ABOVE
Self-Portrait with Small Monkey, 1945
Oil on masonite, 22 x 16 ¼ in.
Dolores Olmedo Foundation, Mexico City

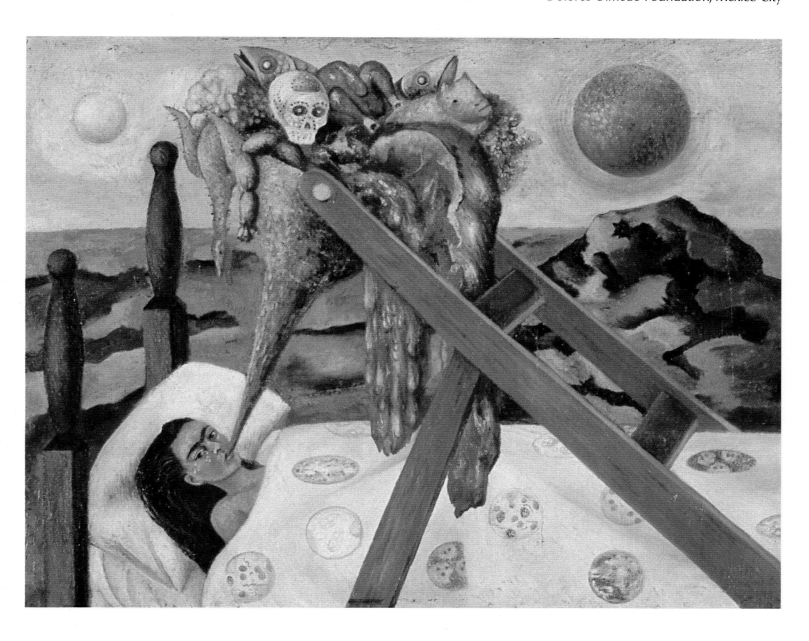

107

LEFT
The Mask, 1945
Oil on masonite, 15.8 x 11.8 in.
Dolores Olmedo Foundation, Mexico City

BELOW
Moses, 1945
Oil on masonite, 37 x 20 in.
Private Collection, Houston

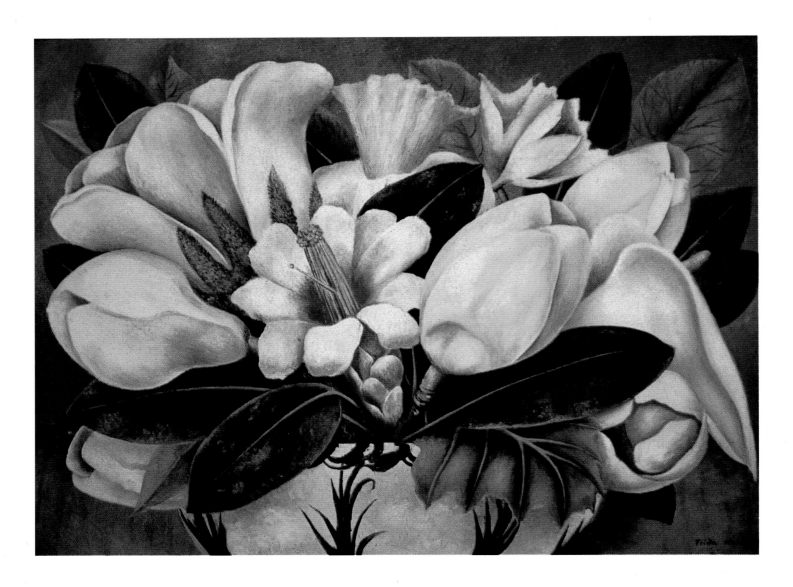

ABOVE
Magnolias, 1945
Oil on masonite, 16 x 22 ¼ in.
Private Collection

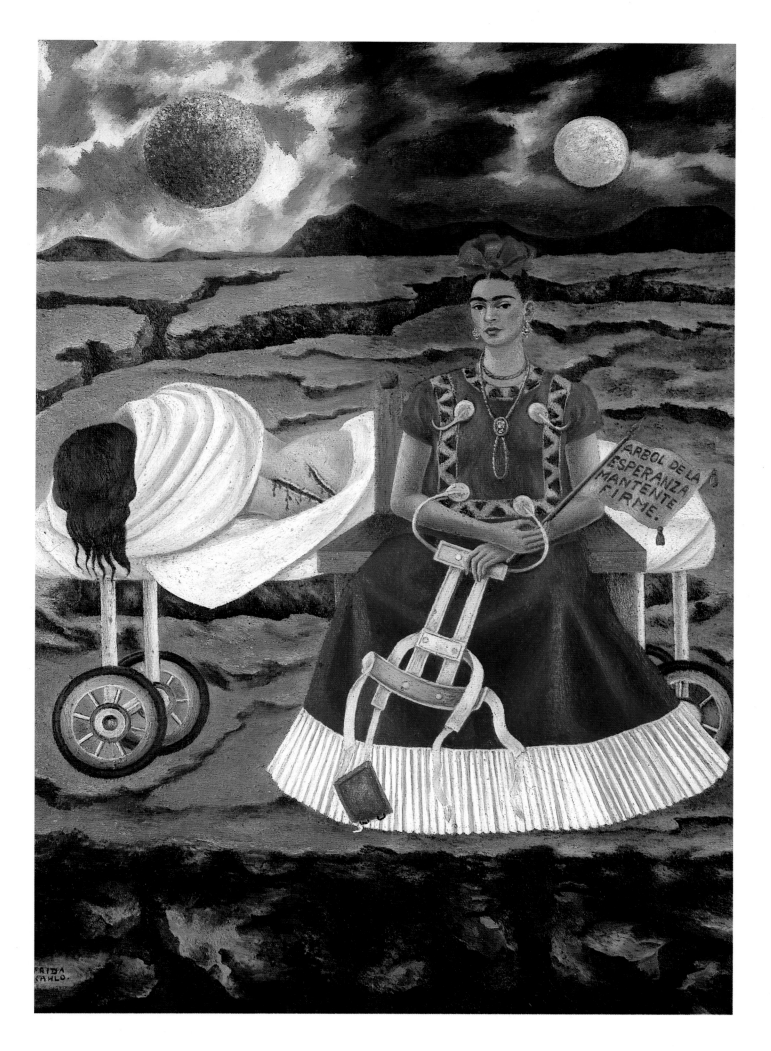

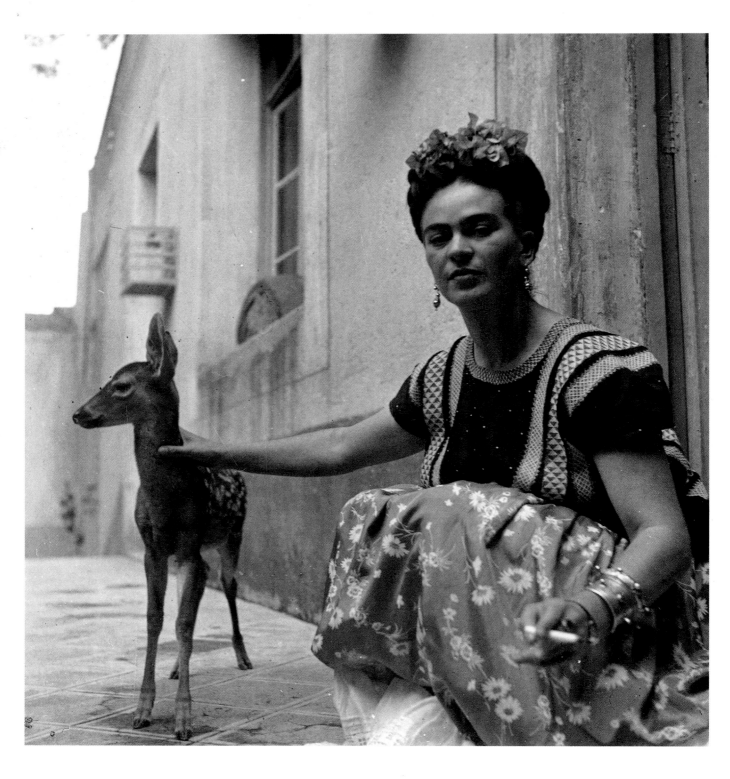

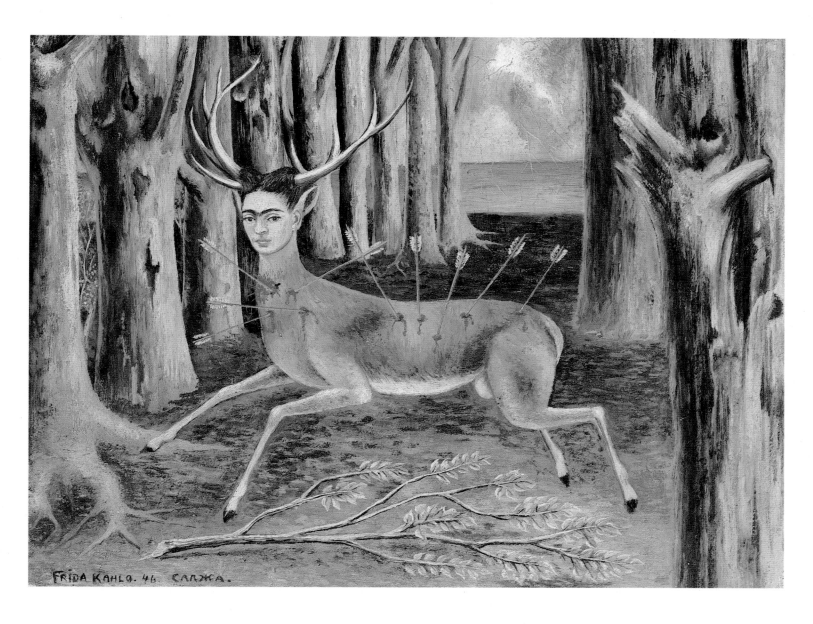

The Little Deer, 1946
Oil on masonite, 9 x 12 in.
Collection of Mrs. Carolyn Farb, Houston, TX

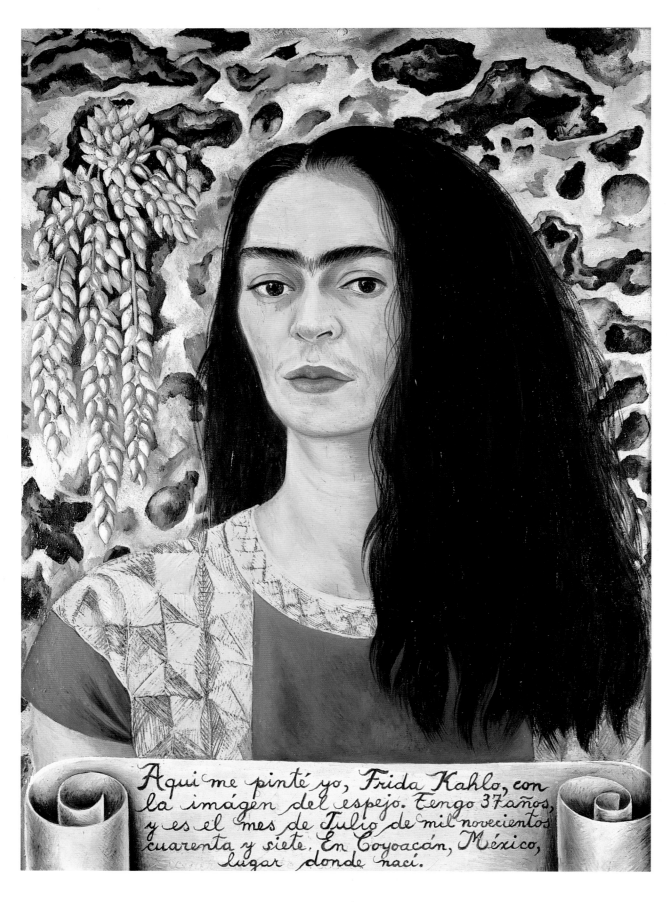

Aqui me pinté yo, Frida Kahlo, con la imágen del espejo. Tengo 37 años, y es el mes de Julio de mil novecientos cuarenta y siete. En Coyoacán, México, lugar donde nací.

ABOVE
Self-Portrait with Loose Hair, 1947
Oil on masonite, 24 x 17 3/4 in.
Private Collection

RIGHT
Diego and I, 1949
Oil on masonite, 11 5/8 x 8 13/16 in.
Private Collection

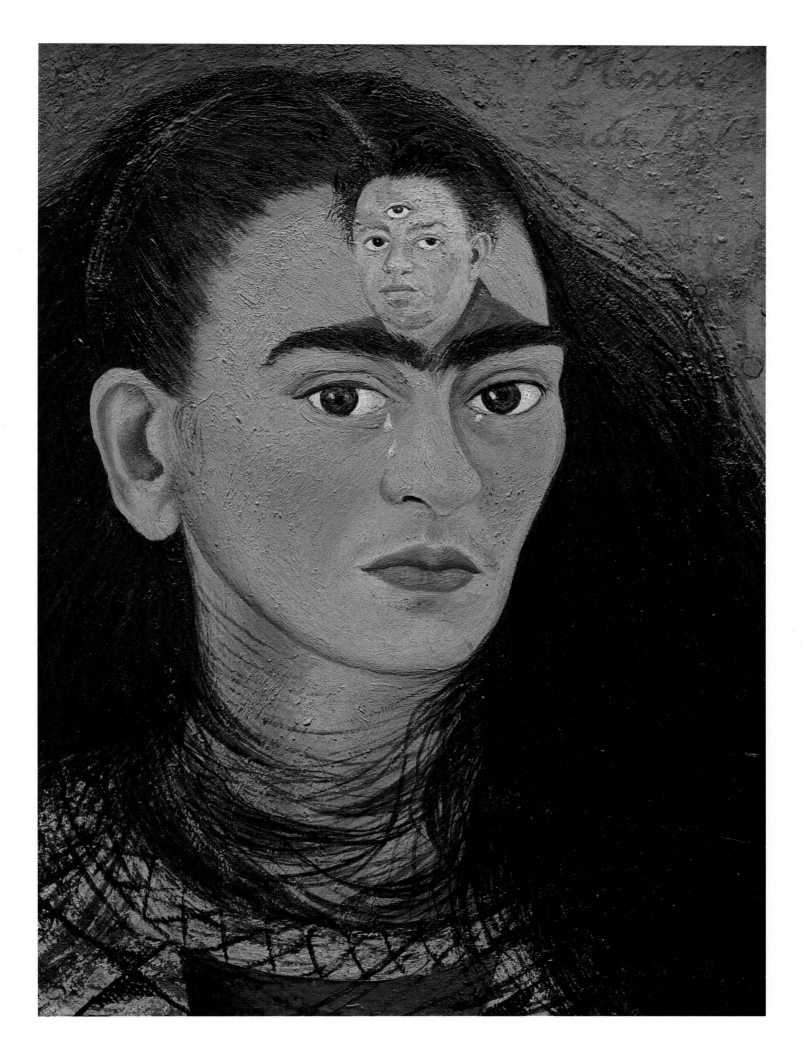

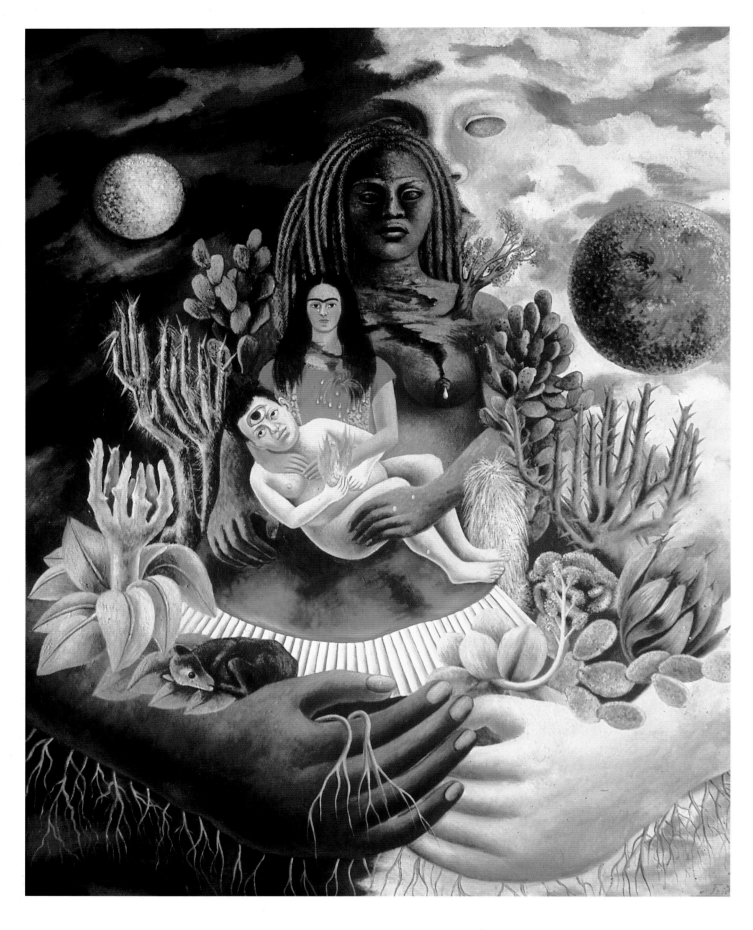

The Love Embrace of the Universe, The Earth (Mexico), Diego, Me, and Señor Xólotl, 1949
Oil on canvas, 27 ½ x 23 ¾ in.
Jacques and Natasha Gelman Collection, Mexico City

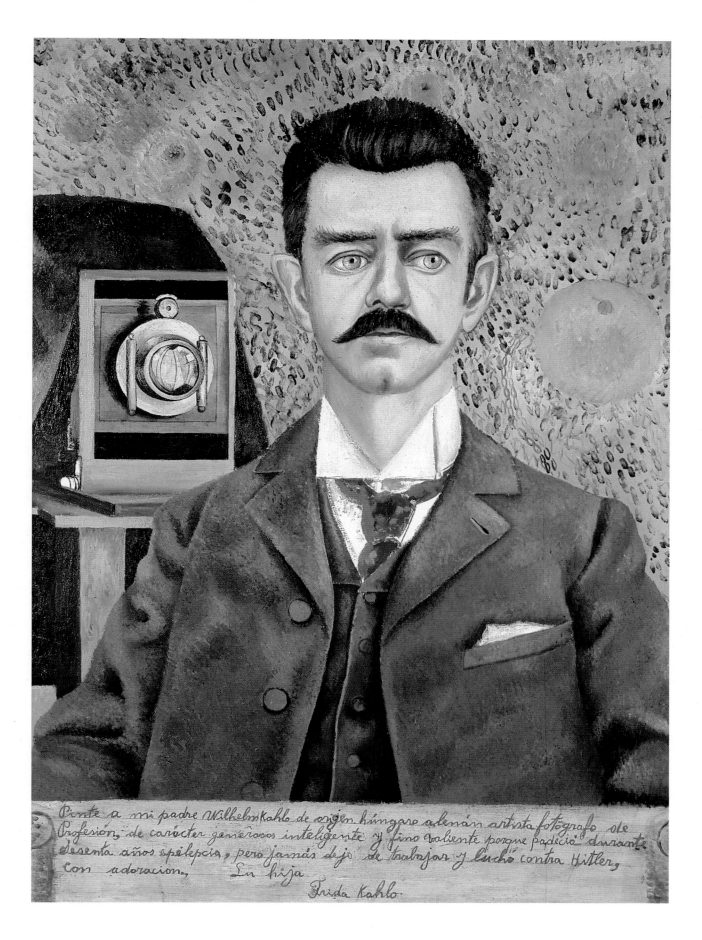

Pinté a mi padre Wilhelm Kahlo de origen húngaro alemán artista fotógrafo de
Profesión, de carácter generoso inteligente y fino valiente porque padeció durante
sesenta años epilepcia, pero jamás dejo de trabajar y luchó contra Hitler,
con adoración, Su hija
Frida Kahlo.

Portrait of Don Guillermo Kahlo, 1951
Oil on masonite, 23.8 × 18.3 in.
Frida Kahlo Museum, Mexico City

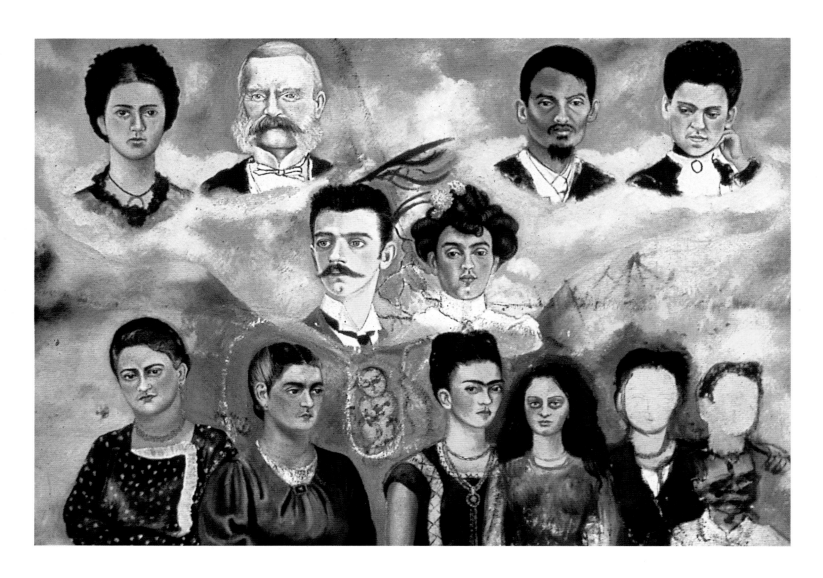

My Family, 1951
Oil on masonite, 16 $\frac{1}{2}$ x 19 $\frac{3}{4}$ in.
Frida Kahlo Museum, Mexico City

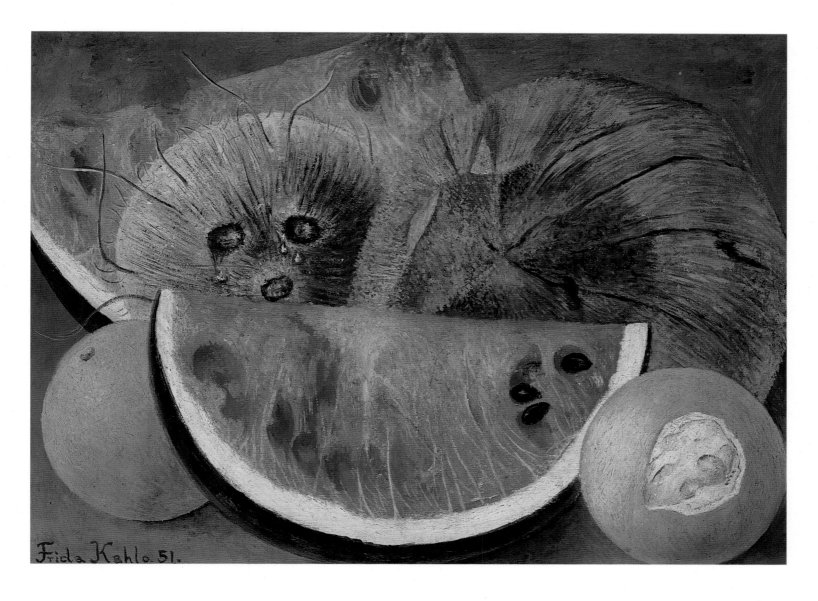

Frida Kahlo 51.

Coconuts, 1951
Oil on masonite, 9 ¾ x 13 ¾ in.
Instituto Nacional de Bellas Artes, Mexico City

Still Life Dedicated to Samuel Fastlicht, 1951
Oil on canvas, 10 ¾ x 14 in.
Private Collection

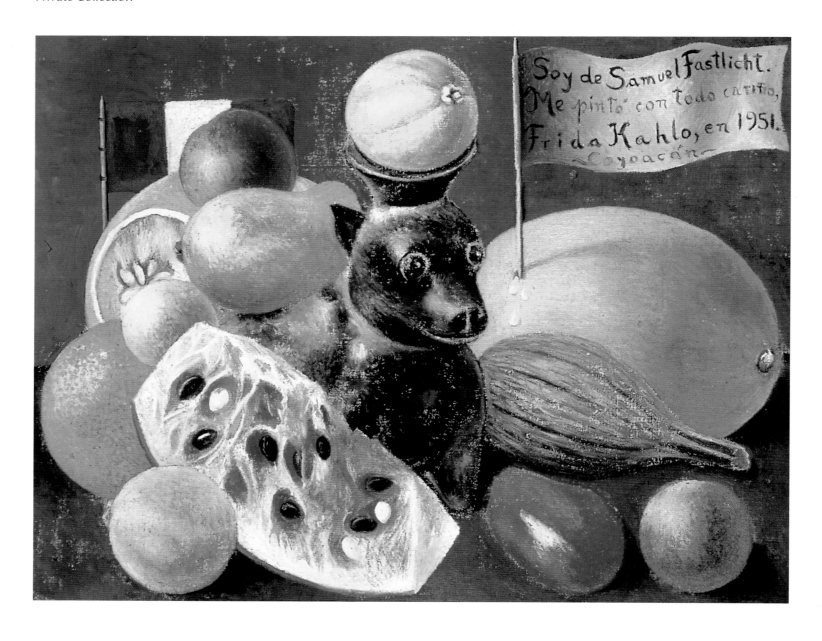

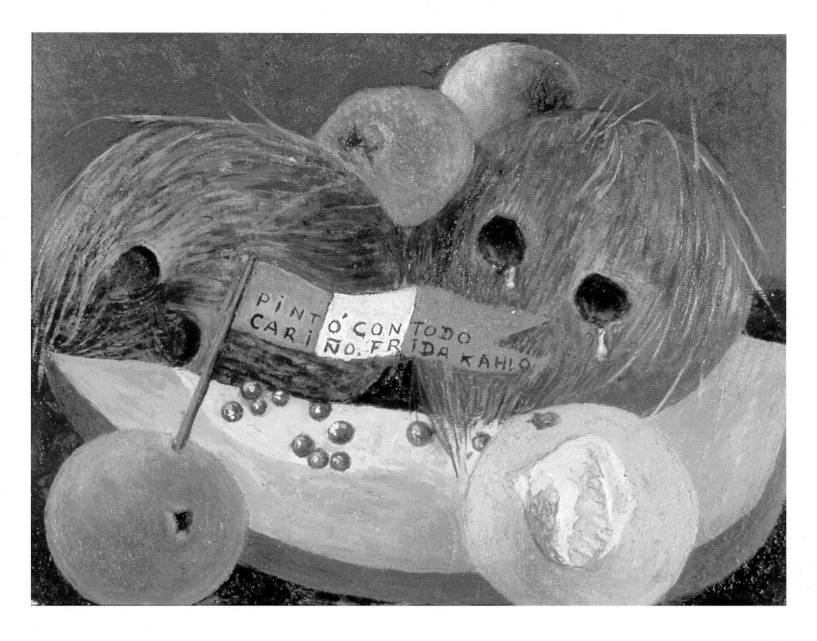

ABOVE
Coconut Tears, 1951
Oil on masonite, 9 x 11 3/4 in.
Personal Property of Bernard and Edith Lewin, Palm Springs

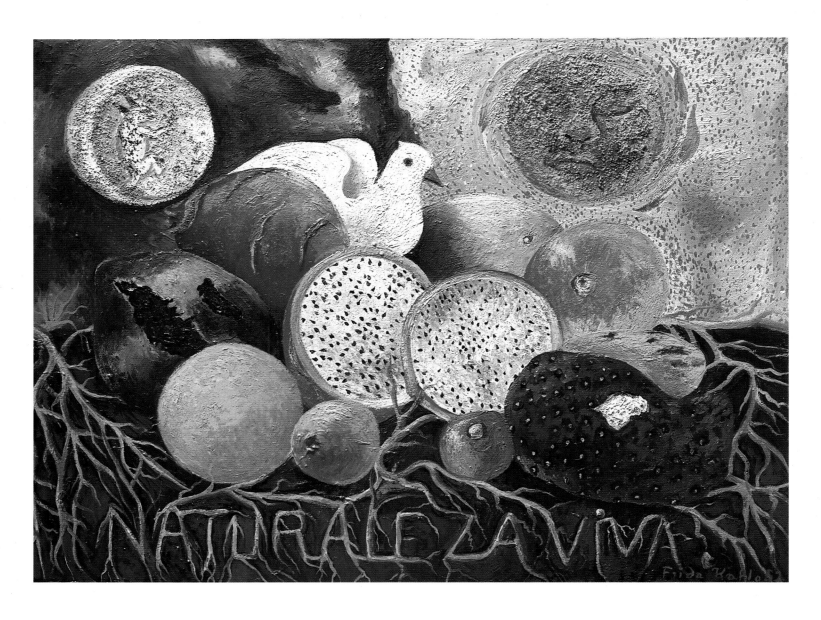

Naturaleza Viva, 1952
Oil on canvas, 17 ¼ x 23 ½ in.
Private Collection

BELOW
Still Life: Viva la Vida y el D. Juan Farill, c. 1951–54
Oil on masonite, 15 ⅓ x 27 in.
Private Collection

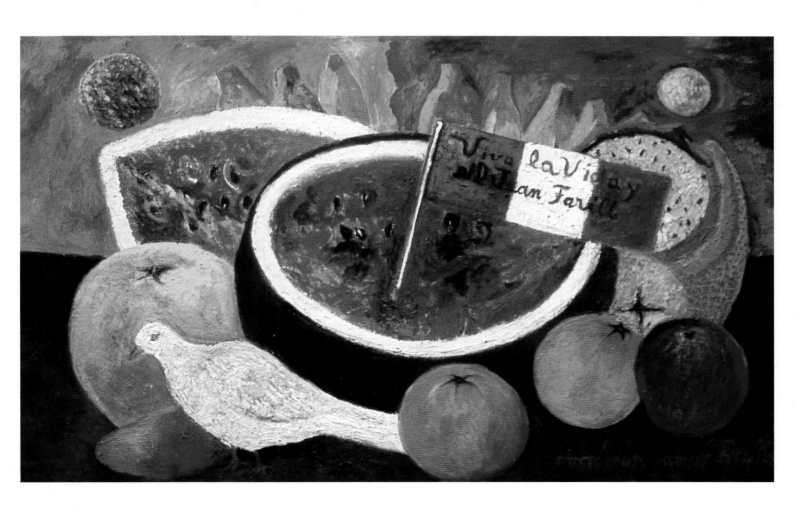

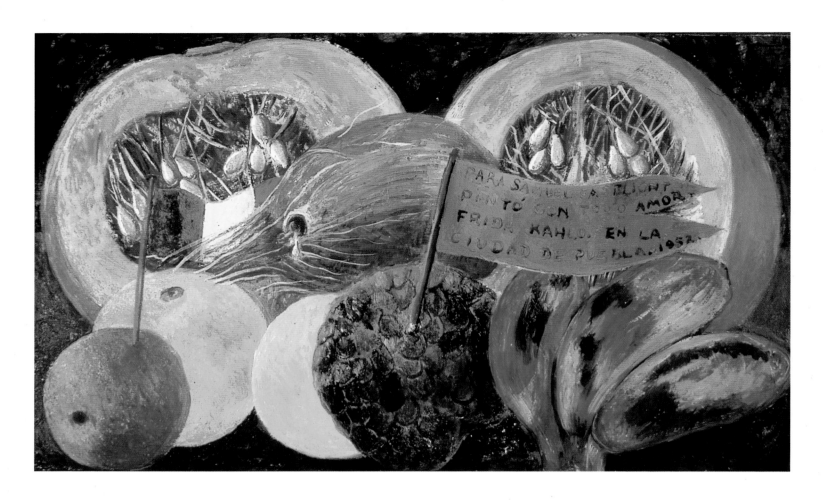

Still Life Dedicated to Samuel Fastlicht, 1952
Oil on canvas, 11 ⅓ × 17 ⅓ in.
Private Collection

Marxism Will Give Health to the Sick, 1953–1954
Oil on masonite, 30 × 24 in.
Frida Kahlo Museum, Mexico City

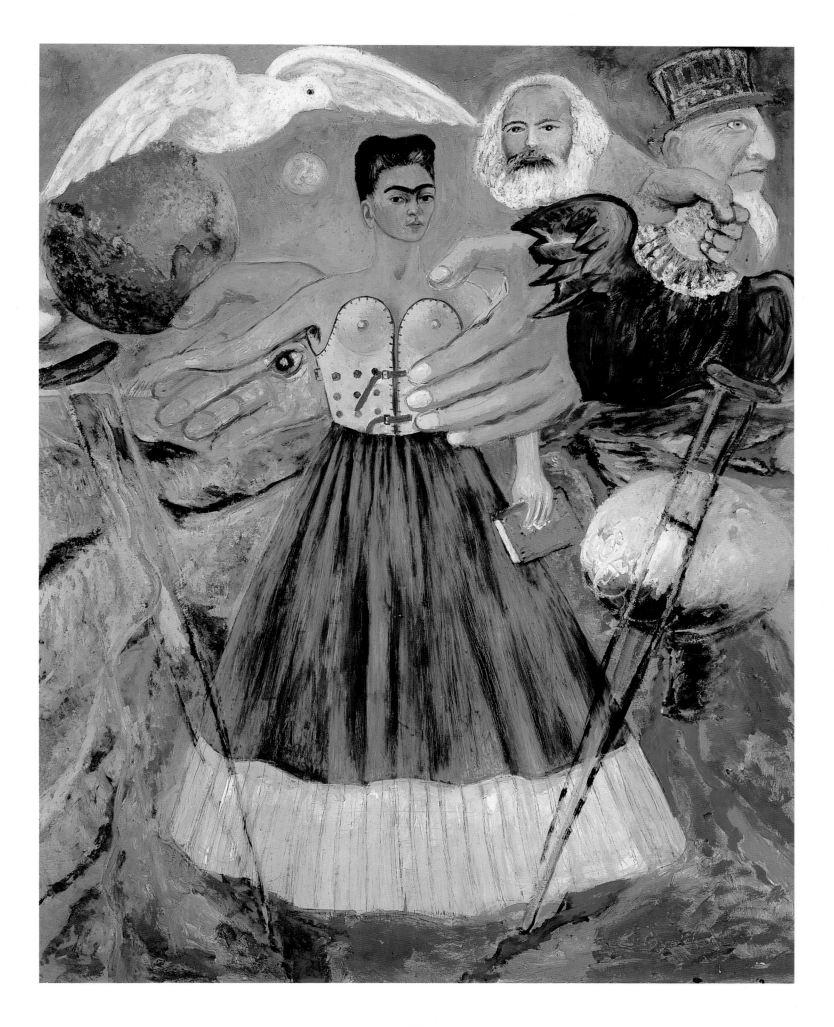

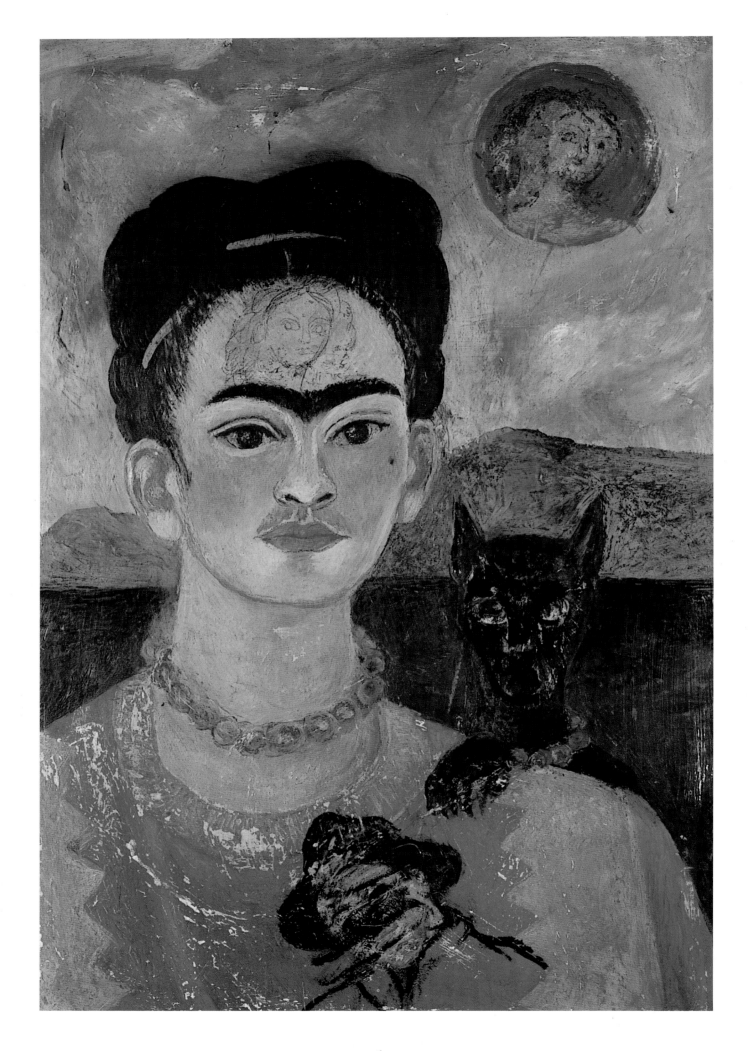

Self-Portrait with Diego on My Breast and María on My Brow, 1953–54
Oil on masonite, 24 x 16 in.
Private Collection, USA

Viva la Vida, 1954
Oil on masonite, 23 ⅓ x 20 in.
Frida Kahlo Museum, Mexico City

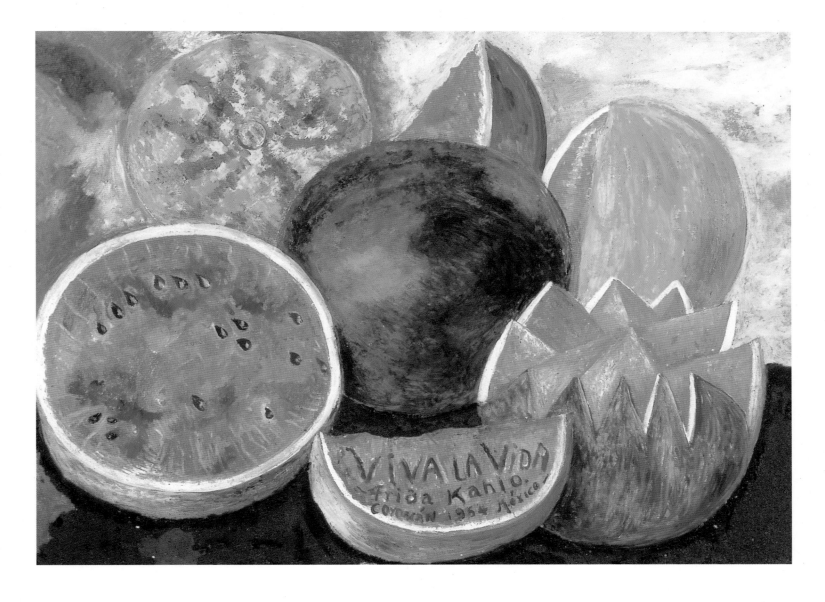

LIST OF PLATES

PHOTO CREDITS

Florence Arquin: 32 (both).
Corbis/Bettmann: 21, 26 (top), 31(top), 38.
Peter A. Juley/Smithsonian Institution, Washington, D.C., neg. # PPJ33256: 19.
Guillermo Kahlo: 9.
Nickolas Muray, courtesy Mimi Muray: 7, 30.
Museum of the American Indian, New York, NY: 11.

ARTWORK IN INTRODUCTION

PAGE 8: Sketch for *My Grandparents, My Parents And I*, 1936
Pencil on paper, 12 × 13 ³/4 in.
Private Collection
PAGE 10: *My Birth*, 1932.
Oil on metal, 11 ⁷/8 × 13 ⁵/8 in.
Private Collection, USA
PAGE 12: *My Nurse and I*, 1937
Oil on metal, 11 3/4 × 13 3/4 in.
Dolores Olmedo Foundation, Mexico City
PAGE 13: *They Ask for Airplanes and Get Straw Wings*, c. 1938
Oil on canvas
Whereabouts unknown
PAGE 14: *Retablo, The Accident*
Oil on tin
Measurements and whereabouts unknown
(Ex-Collection Cristina Kahlo)
PAGE 15: *Cityscape, Red Cross*, c. 1925
Oil on canvas, 13 ¹/2 × 15 ³/4 in.
Private Collection
PAGE 16: *I'm Sending You my Picture...*
Pencil on paper, 5 ¹/2 × 3 ¹/2 in.
Private Collection

PAGE 17: *Self-Portrait*, c. 1922
Tempera on plaster wall, 27 ⁷/8 × 19 in.
Private Collection
PAGE 18: *Portrait of Lupe Marin*, c. 1929
Oil on canvas, measurements unknown
Destroyed by the sitter
PAGE 22: Sketch for *Portrait of Luther Burbank*, 1931
Pencil on paper, 11 ⁷/8 × 8 ¹/2 in.
Private Collection
PAGE 23: *Portrait of Luther Burbank*, 1931
Oil on masonite, 34 × 24 ¹/3 in.
Dolores Olmedo Foundation, Mexico City
PAGE 24: *Frida and the Abortion*, 1932
Lithograph, 12 ¹/2 × 9 ¹/2 in.
Private Collection
PAGE 25 TOP: *Retablo*
Oil on tin
Measurements and whereabouts unknown
PAGE 25 BOTTOM: *Henry Ford Hospital*, 1932
Oil on metal, 12 × 15 in.
Dolores Olmedo Foundation, Mexico City
PAGE 26 BOTTOM: *Frida Photographed by her Father after her Mother's Death*, 1932.
Throckmorton Fine Art, Inc. New York, NY
PAGE 27: Carl Van Vechten
Frida Kahlo de Rivera y Diego Rivera, 3/19/32.
Gelatin Silver Print, vintage, 6 1/2 × 6 1/2 in.
Throckmorton Fine Art, Inc. New York, NY
PAGE 28: *Diego y Frida, 1929–1944*, 1944
Oil on masonite, 5 ¹/3 × 3 ¹/3 in.
Private Collection

PAGE 29 TOP: *Self-Portrait Dedicated to Marte R. Gómez*, 1946
Pencil on paper, 15 × 12 ³/4 in.
Private Collection
PAGE 29 BOTTOM: *Remembrance of an Open Wound*, 1938
Oil on canvas, measurements unknown
Destroyed by fire
PAGE 31 BOTTOM: *The Wounded Table*, 1940
Oil on canvas, 47 ³/4 × 96 ¹/2 in.
Whereabouts unknown
PAGE 33 TOP: *Sun and Moon*, c. 1946
Pencil and color pencil on paper, 7 ²/3 × 6 ¹/3 in.
Private Collection
PAGE 33 BOTTOM: Emmy Lou Packard
Untitled, 1941
Gelatin Silver Print, vintage, 7 ¹/4 × 7 ³/4 in.
Throckmorton Fine Art, Inc. New York, NY
PAGE 34 TOP: Lola Alvarez Bravo
Untitled, c. 1953
Gelatin Silver Print, vintage, 6 × 5 ¹/2 in.
Throckmorton Fine Art, Inc. New York, NY
PAGE 34 BOTTOM: *Ruin*, 1947
Pencil on paper, 6 ¹/2 × 9 in.
Frida Kahlo Museum, Mexico City
PAGE 36: *Fantasy II*, 1944
Pencil on paper, 9 ¹/2 × 6 ¹/3 in.
Private Collection
Reproductions authorized by the Instituto Nacional de Bellas Artes y Literatura, Mexico City